How I Make Photographs
Joel Meyerowitz

Published in 2019 by
Laurence King Publishing Ltd.
361–373 City Road
London EC1V 1LR
Tel: +44 20 7841 6 900
Fax: +44 20 7841 6910
Email: enquiries@laurenceking.com
laurenceking.com

A catalogue record for this book
is available from the British Library.

ISBN: 978-1-78627-580-6

Design: Nicolas Pauly and Florian Michelet

Printed in China

How I Make Photographs
Joel Meyerowitz

Laurence King Publishing

Contents

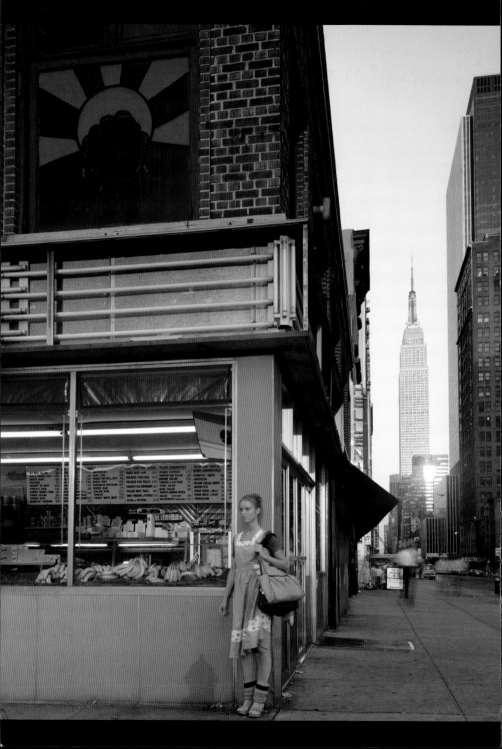

Discover your identity as an artist

Express your vision of the world

Once you have a camera in your hand, you have a license to see. And seeing is what photography is all about. You learn about yourself and the world around you. In the 55 years I've been making photographs, photography has taught me everything I know about the world and about myself.

When I began, I didn't even have a camera. I was an art director at a small agency in New York. I had designed a little brochure and my boss hired a photographer to make the photographs for the brochure. I spent an hour and a half watching this photographer work. I didn't know at the time that he was Robert Frank, one of the most important photographers of the twentieth century. But in that hour and a half, the things he did were so astonishing, as simple as they were, that when I left the location and went out on the street, the world was alive to me in a way I had never before experienced. Every gesture, every incident on the streets seemed to have meaning. By the time I made my way back to the office I realized I had to quit my job and follow that instinct of wanting to be a photographer and to see the way the world showed itself to me.

My boss loaned me his Pentax camera, and that was the start of a half-century journey to fulfil my passion and find my identity. Now you're at the beginning of a journey of your own. The process is all about finding your identity as an artist and as a human being who is interested in the world around you.

Opposite: New York City, 1978

I remember being insecure as a young photographer about how my work was developing. But that's part of it: when you're starting out, when you're trying to raise your game, there's always some doubt. Try to accept that and move ahead, because your photographs are the touchstones that provide you with information, and the act of making pictures builds your confidence.

My goal with this book is to help you develop that confidence and find a way of expressing yourself through photography, which is about looking at the world and seeing just the pieces that make you feel connected to it. It's about those moments when instinct strikes – your moments of clarity, observation and recognition. It's about awareness and impulse, and as soon as it arises, react, do it, go for the picture! Don't think too much. Let the intuitive and physical parts of your being – your brain and body – join in that moment, and you'll make a photograph of something that is disappearing right in front of you. And that is what photography does: it tears a little piece of time out of the whole flow of time and that piece is associated just with you. It is an incredible medium for reflecting the power of ideas and observations.

So have no doubts. As a conscious, thinking person, trust your passions and feelings. Don't hesitate, because in photography, hesitation is loss, and every picture you lose is like a wound. I know; I've lost a few and have learned from those experiences. Have the confidence to try anything.

Above: Self-portrait, 1971
Opposite top and bottom: New York City, 1963

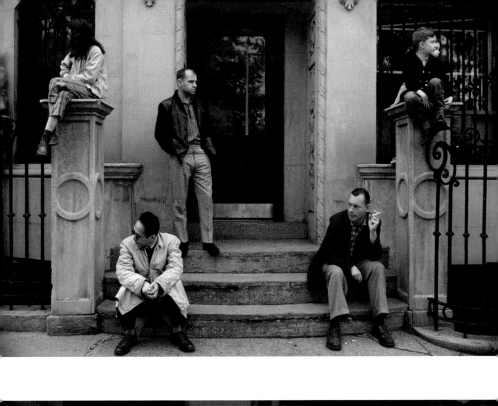

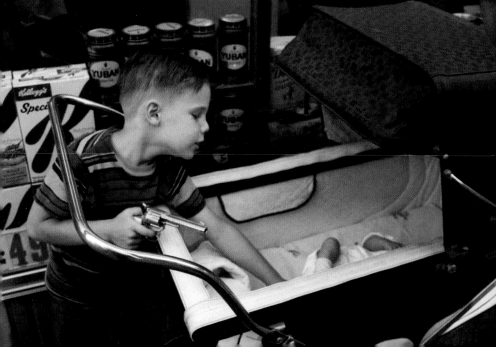

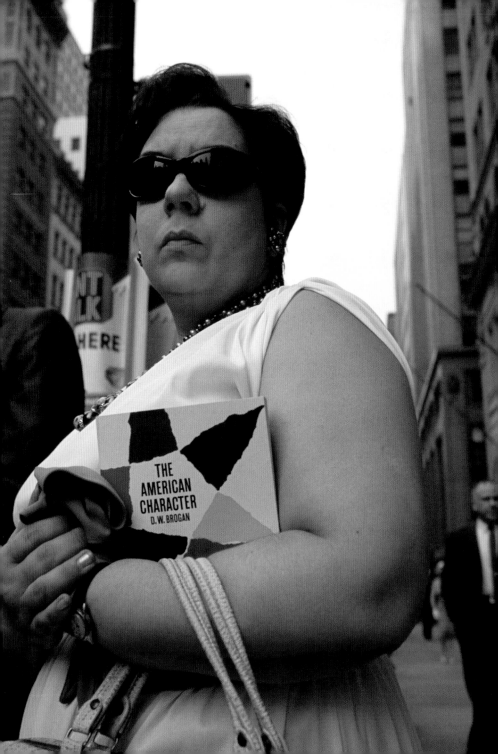

Be inspired

*Immerse yourself in the literature
of photography*

Y ou are very lucky to be living at a time when photography books are abundant. When I began, photography wasn't the recognized art form that it is today. Back then I looked at three books: *The Decisive Moment* (1952) by Henri Cartier-Bresson, *American Photographs* (1938) by Walker Evans and Robert Frank's incredible *The Americans* (1958). They came to me in the course of my first year as a photographer and changed my life.

I mention this because it's important to have access to the literature of photography – not to copy from these artists but to find inspiration in their work, which will in turn spark creative impulses in you. Cartier-Bresson, Evans and Frank developed their instincts and became artists of great significance; finally they were able to bring their work together in book form. Their books have become part of the history of the medium.

When I look at these books, it's like entering a dream. The experiences of these photographers, the locations and the identities of the people and places they photographed are available to you and can serve as a means of drawing a comparison between your photographic impulses and theirs. It's not about making photographs that look similar to theirs; rather, it's a case of recognizing and tapping into your particular instincts and responses to the incredible generosity of experience that the world offers.

Opposite: New York City, 1963

There are remarkable, unexpected and fleeting poems in the pages of these books. Any page you land on demonstrates how the photographer had the good sense to stop, at that moment, in the middle of an ordinary street or a landscape, and let intuition come to them: 'I'm here, now, in this place. This is what it looks like!' By looking at these books, or others with which you identify, you are accepting an invitation to enter those singular photographic moments and learn how to recognize others on your own.

Use books as a library of ideas to encourage you to go out and search for the things that make you feel that your instincts are valid and valuable. I've used books to inspire me during my whole life as a photographer. There will be days when you feel as though you've nothing to say, it's all boring, there's no point in going out. You'll find a lot of excuses – everybody does. When you feel that way, pick up a book and it will charge you with desire again. You'll want to go out and do the same thing. A photographer like Cartier-Bresson knew how to ignite that kind of enthusiasm for seeing in the everyday.

Let's look at this photograph opposite by Cartier-Bresson. How did he make it? How did he *know* to make it? My guess is that the uncertain arrangement of windows probably first caught his attention. There's no regularity there. He probably thought, 'Wow, this is a great background. I'm going to hang out here for a while.' Then he noticed that there were children playing a game nearby, so he moved within range of them, knowing they were unlikely to be bothered by his presence.

Together, the children and the wall create an interesting photographic space. Then, because Cartier-Bresson was waiting and watching everything that was happening in this little theatre, which he recognized as being important to him, he saw this man walking through. The man is wearing a hat and, as luck would have it, it is almost the same size as some of the windows. With his big belly and suit jacket open around it, he becomes a dramatic character in this playground. And Cartier-Bresson makes the photograph.

We can break this down into stages. First, there was the inspiration on Cartier-Bresson's part to stop because of the way the building looked. Then there was the sighting of the children.

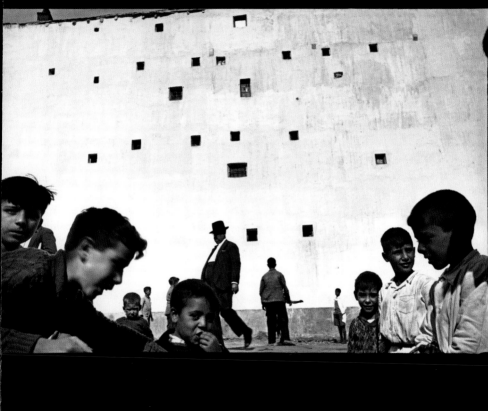

The photographer found his way into the best position to make his picture. Finally, the man entered the scene and the photograph appeared for Cartier-Bresson, all because his instinct had said, 'Stand here a while. Pay attention here.'

Let's look at another kind of photograph, *Identical Twins, Roselle, N.J., 1966*, by Diane Arbus, which is completely different to Cartier-Bresson's, yet just as intriguing and complex. Arbus mostly made portraits. Here, she has photographed twins. What's the first thing we think about twins? 'They look alike. They dress alike. They're twins.' But Arbus is sharper than that. This photograph shows how the girls are not alike, even though they're twins. That quirky reality was intriguing to Arbus and helped her find her way to a simple yet powerful photograph.

Arbus was a humanistic photographer – when she was curious about somebody she didn't just sneak up on them, take their picture and run away. She was able to enter the lives of her subjects and gain their confidence by showing them that she was interested in their specialness. When she expressed her interest, through gesture or words, her subjects opened up and allowed her to see and photograph their mysteriousness – because photographs can describe the mystery of others.

The act of making a photographic portrait is one of those intimate moments of connectivity between human beings, between the photographer and his or her subject (see Chapter 6). It reveals a lot about the person who is making the photograph, as well as about the person being photographed. You'll learn a great deal if you start to photograph the people around you: family and friends, neighbours and shopkeepers; people who trust you and are willing to open themselves up to you, or at least give you the time to discover your own way of engaging with them.

I'm not talking here about family album snaps, but rather about photographs that show the mystery, essential qualities, tenderness, physical beauty and magic people have when they express themselves, when they reveal themselves. This is part of the art of photography – how to work with your human capabilities and communicate your needs to others so that they, in turn, yield themselves to you.

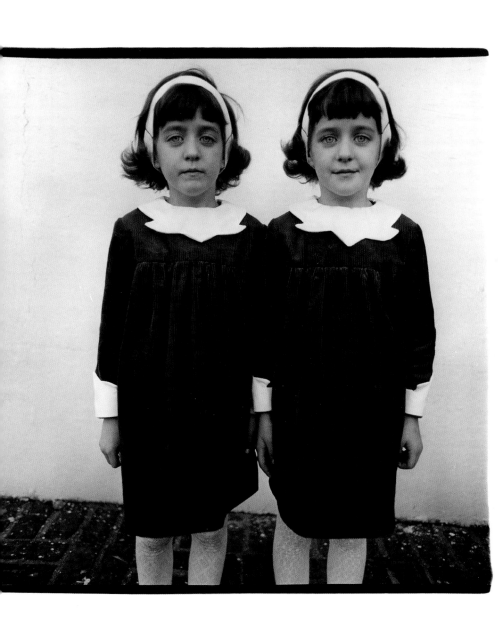

Diane Arbus, *Identical Twins, Roselle,*
N.J., 1966

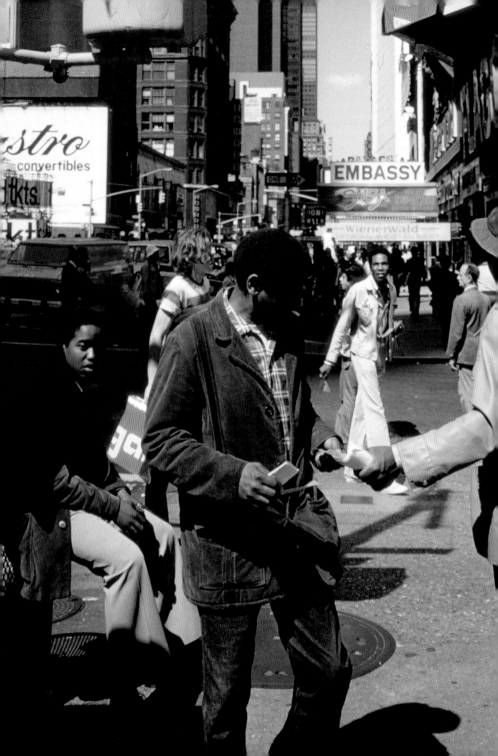

Own the street

You have a right to be in public spaces, so shoot with confidence

I've been asked many times, 'How do you work on the street? I'm afraid to work on the street, I'm too shy, I can't take pictures of strangers because I shouldn't really be taking their picture.' People have a kind of mythic fear about photographing in public spaces. My feeling about the street, and street photography, is that the street is ours. Once you enter a public space, everyone and everything there is fair game.

So how do you go about making a street photograph? First of all, you must have an appetite for life on the street. The street is chaos. If you are comfortable in chaos, you'll find your way. When you're on the street, it's important to be able to see across the entire frame. You own the territory that you see when you look through the viewfinder of your camera. One of the most interesting qualities of street photography is making connections between things that are not related, because when you put the frame around them you create a new relationship.

One of the great fears that everyone has is that if they take a picture of someone on the street, that person will be insulted, or will attack them. But the fact is, a simple smile and being good-humoured goes a long way. So if you're on the street and everything you see when you're taking pictures makes you smile, you're already a softer, more approachable, more human person. People won't feel negative toward you. But if you're standing there with

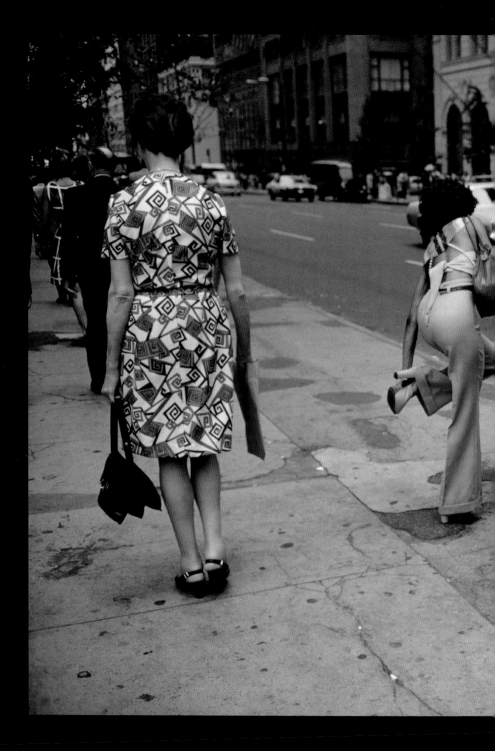

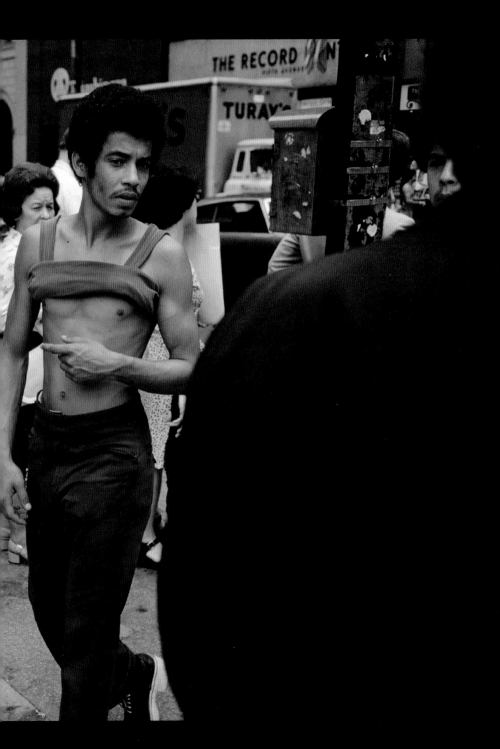

a 200mm telephoto lens that you're waving in someone's direction and they catch sight of you, they're going to be on their guard and maybe even angry. They're going to say, 'Hey, get out of my way.'

Being quick and being happy and excited about what you're doing sends out an aura of, 'This person's OK. I don't have anything to worry about.' What is important is intuition, being positive, having a sense of humour and being in the right place at the right time. Always have your camera turned on and its lens cap off. Touch the button frequently, if it's a digital camera, so that it's always ready to shoot. All these things are part of your basic preparation for being a photographer on the street.

There are a lot of subjects that people think are off-limits: you shouldn't photograph people with infirmities, for example. Opposite (top) is a photograph that illustrates my feelings about this. I was walking down the street and I see a guy carrying flowers. I keep walking to find a position to make a photograph. At the moment I get near the guy, a woman with a big bandage across her nose appears next to him in the crowd. So I made a photograph. People might say, 'Oh no, but she's, you know, look how she looks.' But it doesn't matter. It really doesn't. In a way, photographing people with infirmities or injuries is, at its most basic, acknowledging their existence.

We must be humble enough to recognize that we're all humans, and we come in every shape, size and colour. You're not making fun of anybody; you're telling it like it is. This is how the world looks, and these are the ways people interact. I believe everyone is fair game as long as you're not trying to take advantage or being cruel. From a humanistic point of view, the sweetness of photography is its capacity to embrace everybody in every kind of situation and to make works that come from the heart. That way, what you say through your pictures to the world at large is that you are warm-hearted, generous, sympathetic, vulnerable and open. This doesn't mean you can't be tough about getting what you see, however. Street photography is a tough field to work in, and demands a sharp eye and a resilient nature.

Opposite top: New York City, 1974
Opposite bottom: New York City, 1963
Overleaf: New York City, 1976

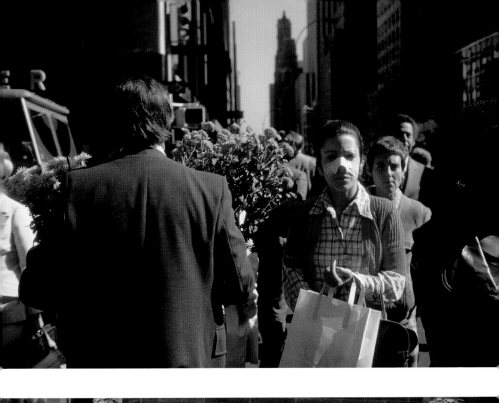

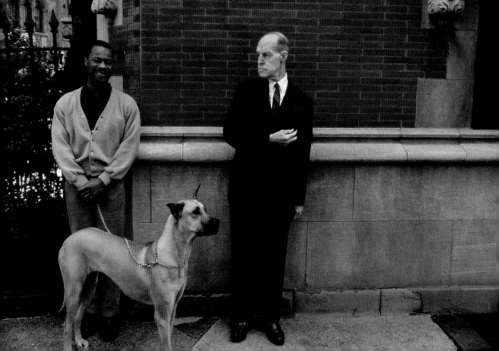

Embrace the everyday

Uncover beauty and significance in the ordinary

Once in a while, and usually for the briefest of moments, we are startled by something *out there on the street, right in front of us* that makes us gasp with recognition of the pure beauty of that moment. The moment is already disappearing while the gasp fills our lungs and our minds light up. That is your photographic moment, and only you can know it.

If you immerse yourself in street life, for example, by hanging out on a busy corner, sooner or later you're likely to see something that calls out to you: people moving this way and that, and all kinds of interesting gestures and faces and combinations of things happening. Gradually, the boredom or the blankness you might be feeling goes away, because you're watching ordinary things unfolding their possibilities right in front of you. Then, because you're there, something out of the ordinary will come along and suddenly you'll see how interesting it is. Photography is all about responding to the things that call your attention, and staying connected to them.

Really, photography is a very optimistic sport. You press that button, and you're saying, 'YES. Yes, I saw that. Yes, I want that.' When you look at your photographs later on you'll begin to see that during the course of that day you were saying 'yes' to a lot of different things, but when you add them up, those different photographs give you a sense of your identity (see Chapter 17).

Opposite: New York City, 1963

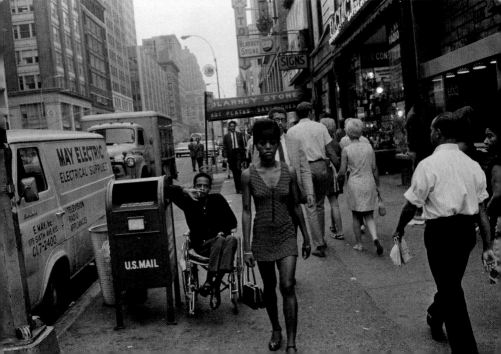

Instantaneous responses don't happen only on the streets in a bustling urban environment. Imagine you're out of town and, out of the corner of your eye, you see some old industrial buildings, a factory, a smokestack, warehouses, and you're curious. When that happens, get out there, wander around, and see what happens.

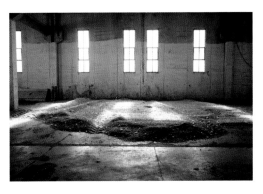

I did just that when I was passing an industrial site on the outskirts of a small town in Tuscany, while we were filming some of my tutorials for the Masters of Photography course.

I went into one of the buildings and saw what could have been an installation in a museum: white bags full of sawdust arranged in a pile (there were also heaps of sawdust nearby, see above), sunlight streaming in through a window on to the bags and a pile of logs in a corner. Noticing one thing and then the others, I tried putting these elements together to make a frame about their unlikely relationship. All this came together in my mind's eye to create a striking environmental still life within what was, in truth, just an ordinary, forgotten space.

So when you come across a scene that interests you, explore it. Photograph it in different ways and in different combinations. On this occasion I first photographed the pile of bags, then the bags with the sawdust, then the bags with the wood and finally just the wood.

My process begins with having a sense of awe. When I start to feel that, I go with it. Keep your eyes open and see what you can discover. If you follow your instinct – and this is really what it's all about – and go where desire sends you, you're likely to see unexpected, magical things. Think of the camera as giving you a gift. The camera is saying, 'Go, go, take me somewhere – take me on an adventure.' Whether you're at an industrial site outside of a small town or walking through a plaza in a major city, it's all there waiting for you.

Above: Warehouse, Tuscany, Italy, 2017
Opposite top: Málaga, Spain, 1966
Opposite bottom: New York City, 1969

Embrace the everyday 27

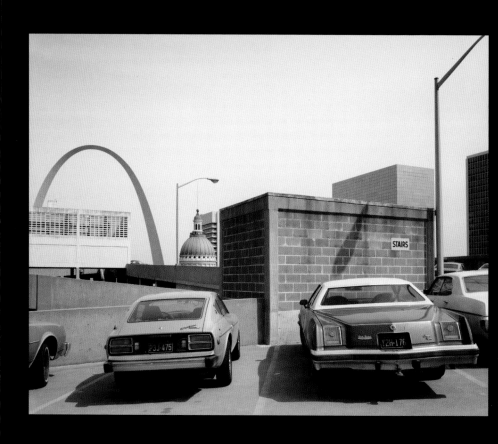

St. Louis, Missouri, 1978

St. Louis, Missouri, 1977

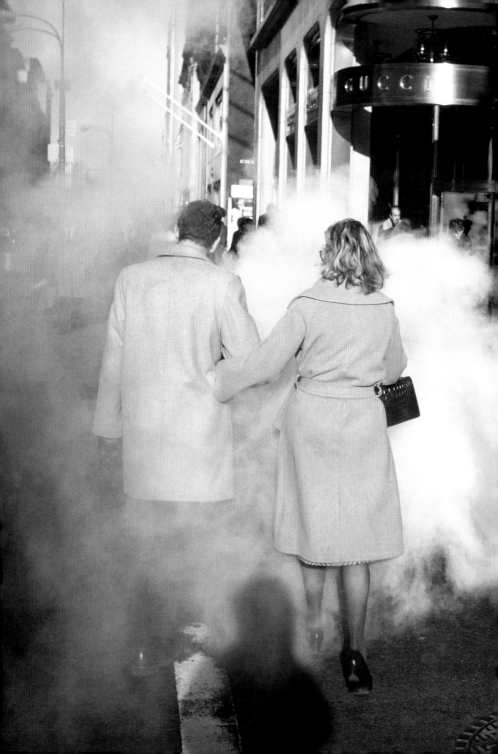

Anticipate
a moment

Be present and ready to react

One of the great joys of being on the street is staying alert to the unexpected. As a young kid I grew up in the Bronx, in a real tough, working-class neighbourhood, and my father, who was a street-smart New Yorker and an athletic man (a professional boxer, in fact), taught me how to protect myself so I wouldn't get hurt in street rumbles. He showed me how to bob and weave and to feint – to encourage someone to look elsewhere – so I could throw a shot.

My father also taught me to look at life happening in front of me. He would often whisper, 'Joel, look at that', or 'watch this'. And wherever he pointed, something would happen. Somebody would slip on a banana skin, or bump into a pole or stop and have a conversation with someone and then they'd wrestle each other a little. He always seemed to have an idea of what might happen, and by pointing it out to me and saying, 'Watch this', he taught me to read the street.

In a way, being a photographer came very naturally to me, from a childhood awareness of having to look out for myself and an understanding that the world repeats itself over and over again.

People have always walked into doors, fallen off steps, fought, made eye contact or gestures of anger or love. Humans do the same things all the time. If you understand that, you can watch the world with a sense of the possibility that these things are

going to happen. You can almost predict movements, gestures and actions. That way, you're always a little ahead of the game. You're ready to step into the right space at the right moment, near enough so that when an event happens, you're there.

How is it that when you look at the work of someone like the master Henri Cartier-Bresson, it seems he was always in the right place at the right time? His pictures are testimony to the fact that he always understood, always anticipated, predicted and arrived just where he should be when the moment happened. Everyone has this capacity for understanding, for anticipating, and you too will be able to make the kind of photographs you think you would only see in magazines.

Opposite (bottom) is an example. What's going on in this image? I was walking down a street in New York and saw a big puff of steam from an underground vent. Part of what is inspiring about photography every day is the moment something signals you. In this case it was a puff of steam, but it could be as simple as the way a truck comes past, or someone wearing a crazy outfit; anything that says, 'Hello, I'm talking to you.' When you receive a signal, pay attention. Paying attention is the basic act of photography.

I saw that puff of steam and moved toward it because to me it was a screen in the middle of the street on to which people's shadows were being projected. Just as I walked up to it, a couple wearing matching camel-coloured coats appeared. Then two other people in coats of the same colour came into view; imprinted on their backs were people's shadows.

This all happened in a split second, the time it takes for a photograph to come into being. When the little dial on your camera says '1000th of a second', that means in one second you could, in theory, have 1,000 pictures. But you've taken the one that really matters.

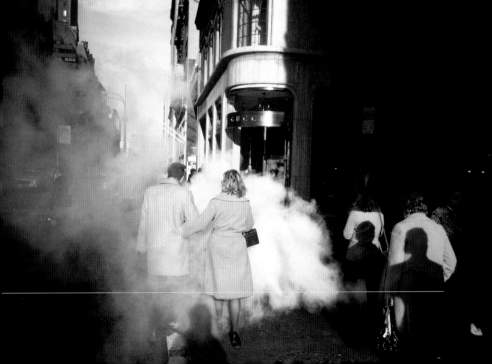

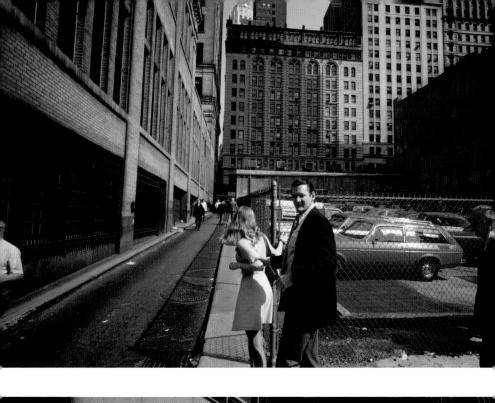

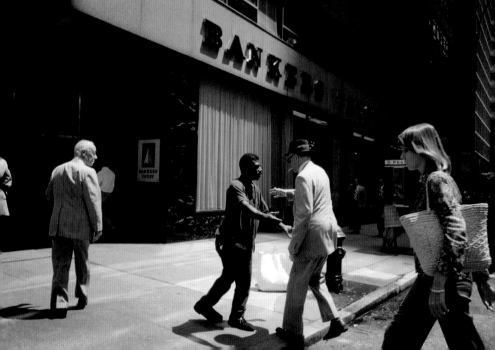

This picture has a kind of 'twinning' quality, a kind of serendipity. Nothing major is happening, but the fact that these two small incidents appeared together, literally in a puff of smoke, is like a magician's trick. Poof! Now you see it. And then it's gone!

The photograph opposite (below) is an example of ambiguity, even though the action is clearly described. Ambiguity is one of photography's native strengths, and it will be yours too once you have learned to see it when it's unfolding. What's going on here? A black man and a white man momentarily confront one another on a sidewalk. One man has outstretched arms while the other reaches forward with his right arm. Are they about to embrace? Dance a little jig of recognition? Is one resisting and the other pleading? Is it dangerous? One passer-by takes note, while another doesn't even notice. But I did. I recognized a decisive moment with an unknown meaning and outcome. That's what a photograph does. Only with quick intuition and a deep understanding of the human possibilities can you walk the line of ambiguity.

Photography happens that fast, right in front of your eyes. When a magician shows you how he did a trick, you suddenly see what you hadn't seen before, even though you were looking right at it.

Similarly, a photograph shows itself to you, but only if you're quick enough to see it can you make magic out of it. Really, that's who we are – magicians with cameras.

'Being a photographer came very naturally to me, from a childhood awareness of having to look out for myself and an understanding that the world repeats itself over and over again.'

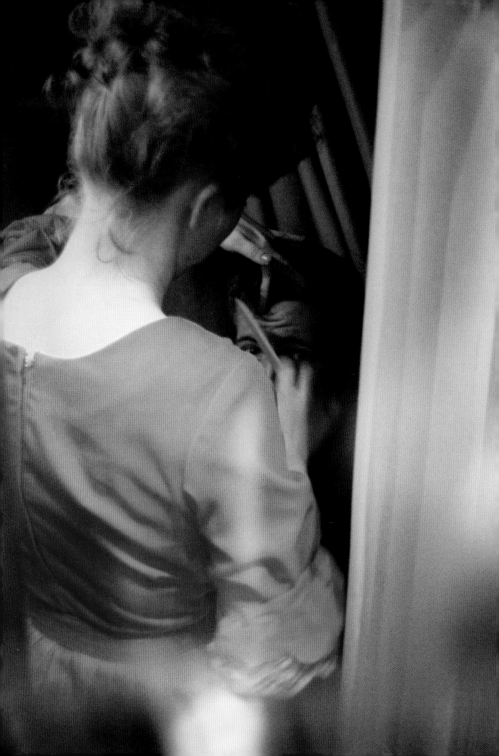

Make connections

Create relationships with the people and places you encounter

As we are starting to see, creating a meaningful street photograph is about awareness. It involves making connections with what is happening around you. In this chapter I want to talk about how to connect with the people you encounter on the street, by the beach, at an event or wherever, in order to make an environmental portrait or a photograph featuring people. Incidentally, 'connecting' doesn't have to involve talking at great length to a person or even talking to them at all. What is important is that there is an understanding.

Portrait photography dates back to the medium's earliest days, in the nineteenth century, and remains one of the staples of photography. There are many interesting ways of making a portrait, but what is a portrait? Is it about the other person or is it about you, the photographer? Or is it the combination of you and your subject? Once you begin making a portrait, a special energy between you and the subject comes into being. You have entered their private existence and engaged with them, and they have accepted your move. No matter how light your touch, a new force will pass between you, and in that sense the portrait will contain something of what you bring to the encounter. What that could be depends on who you are during the few moments of your interaction, and what you can discover about them at the same time.

Opposite: New York City, 1962

Making a portrait in a public space is a very fluid situation. One approach is to go over to a stranger and say something like: 'There's something about you that moves me; may I make a portrait of you?' And then you have to follow up by being charming enough that they say, 'Yes, I'd love to have my portrait made by you.'

How you go about making a portrait is up to you, but consider where the person is in the frame. Perhaps you could start close in, so you're just dealing with eyes, nose and mouth, and then pull away so you're seeing only the person's head, then half of their body and then the whole figure, until finally the figure is small in the frame with a lot of space around it.

Mostly portraiture is about seizing opportunities. Below is an example. I'm coming out of a restaurant in Siena and see the chef standing outside. I thank him for the meal, and as I look at him I think, 'This guy's worth a photograph. There's something about him.' So I make a formal portrait. I like the detail behind him and the beautiful old wall. The chef stands very simply. I'm making a picture of two things, essentially: age and the history of the place, and a young chef. I try to fill the frame. I like the way the chef's arm hangs, and he has a beautiful kind of statuesque quality and great presence. See how his steady eyes look into the camera.

On this occasion, I was able to work with the chef and ask him to participate in the making of a picture. We had a good 'thing' between us. When making a portrait of a stranger, if you can

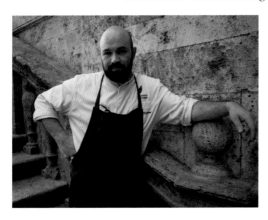

find a connection, the portrait will be more interesting.

Another approach is to walk in and move around a situation, photographing as you go. Once you've found your subject and they've welcomed or at least accepted you, it is about finding the right place to be and then just playing.

The image overleaf (right) shows work that involves using one's hands: a woman crocheting. What's

important is that these things are happening in a medieval courtyard in a small Italian town. The picture of the woman is OK, but to see *where* she is, that's what's interesting to me. I'm in their lives for a moment – and I'm making a portrait about life in Italy.

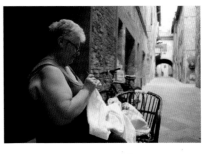

I tried to make the background and the subject come together in an interesting way in order to push the boundaries of the photograph. I moved all the way around the woman so that I could see how this moment was unfolding, photographing her hands, her body, and then finally her figure within the background. A portrait isn't only of a person; it can also be of a place. It is important to put these things together in a way that fits and becomes more interesting.

Think about bringing the person close to you, metaphorically and photographically speaking. Leave a little space, maybe, for something in the background to be seen. Or have the person fill the frame. Turn the frame sideways, so they appear on one side with emptiness on the other, or bring a bunch of people in so that they pack the frame. Try many things.

Making a street portrait happens in the moment. It's live, it's now and it's as inventive and playful as you can make it. Part of the enjoyment of making a portrait is the process of making the actual photograph.

'Once you begin making a portrait, a special energy between you and the subject comes into being. You have entered their private existence and engaged with them, and they have accepted your move.'

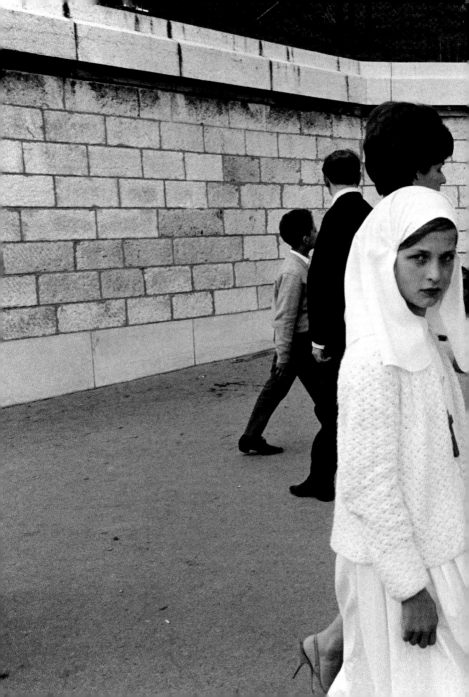

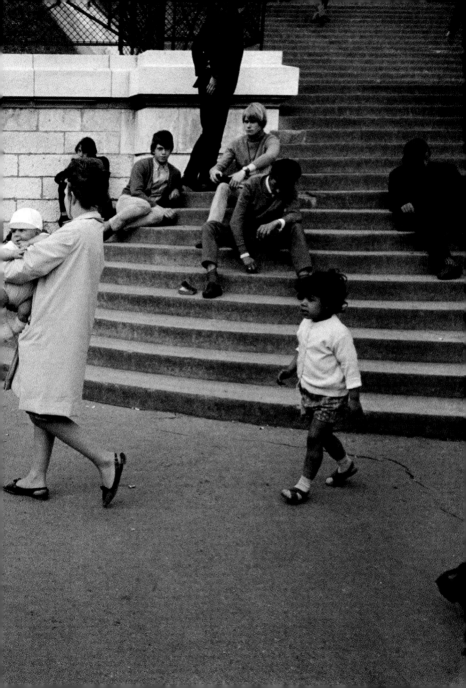

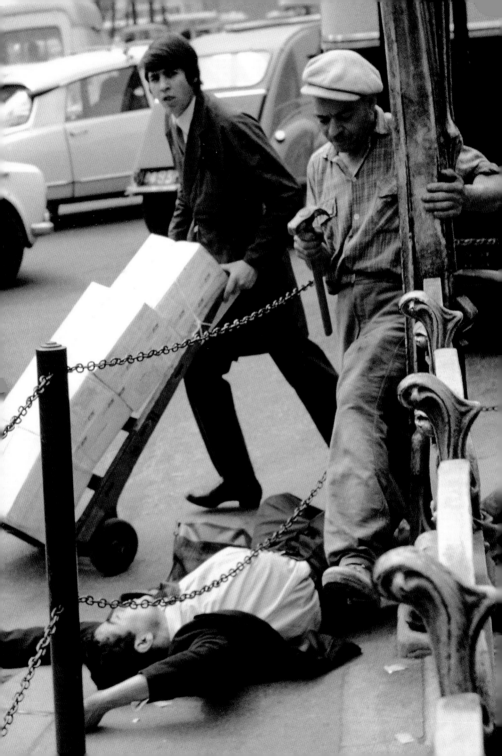

Find the story

Let your images tell tales

Photographs are rich in information. They have the potential to tell stories, not in a conventional narrative way, but in a way that is informed by instantaneous vision as a result of the photographer being present and ready when something happens.

For example, opposite is a photograph I made in Paris (see also pp. 52–53). It was the only picture I made in that moment – there wasn't time for another shot. I was walking along the street and saw a crowd. I felt the energy of the crowd and moved toward it. There, in front of me on the street, was a man who had fallen on the pavement and who seemed to be unconscious.

In the same moment I saw the guy on the ground, I noticed a man with a hammer stepping over him. It looked as though this man had just bludgeoned the other man with the hammer and knocked him to the ground. But of course, it didn't happen like that. The man had fallen down while the character with the hammer was probably just going back to work.

There were people all around: a guy on a bicycle, in traffic, who turned around; another who was walking by and looked back while moving on; a delivery boy passing within a metre of the fallen man; and all these other people by a bus who were bystanders just staring. Not one person went over to help the guy on the ground.

Opposite: Paris, France, 1967 (detail)
Overleaf: New York City, 1963

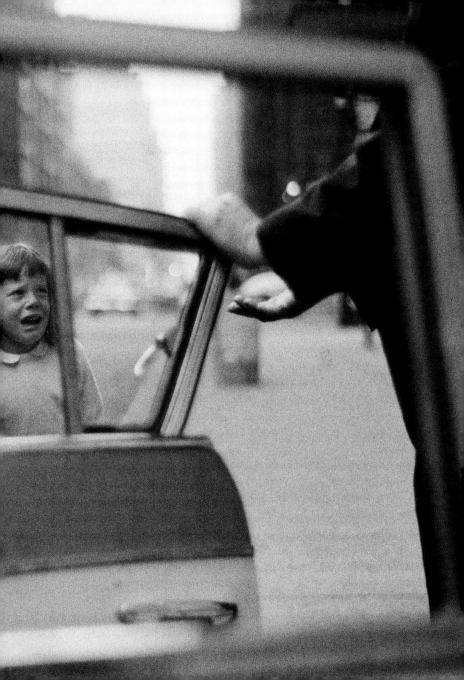

So what's the story in this picture? Is it the interaction between the two men and the possible story that one knocked the other down? Or is it to do with the onlookers not going to the man's aid?

As this image demonstrates, several things happen at once in a photograph. Part of the reality of making images is that they are flexible: they can be read in singular ways, as individual 'heads' in a picture, or they can be read in global ways, with universal meanings about culture, society and the time in which the image was made.

Photography as an elastic medium expresses dramatic content, but it also has the potential to transmit emotions and a sense of the time it depicts. It's a very expansive and expressive medium.

'Part of the reality of making images is that they are flexible: they can be read in singular ways, as individual "heads" in a picture, or they can be read in global ways, with universal meanings about culture, society and the time in which the image was made.'

Opposite top: New York City, 1965
Opposite bottom: Greece, 1967
Overleaf: Paris, France, 1967

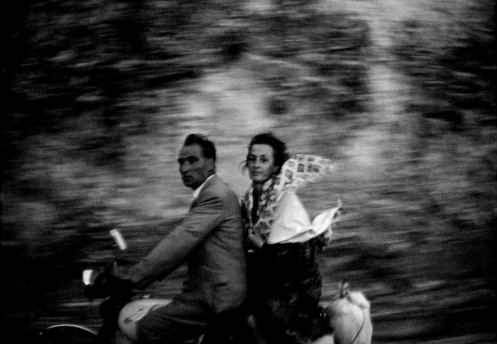

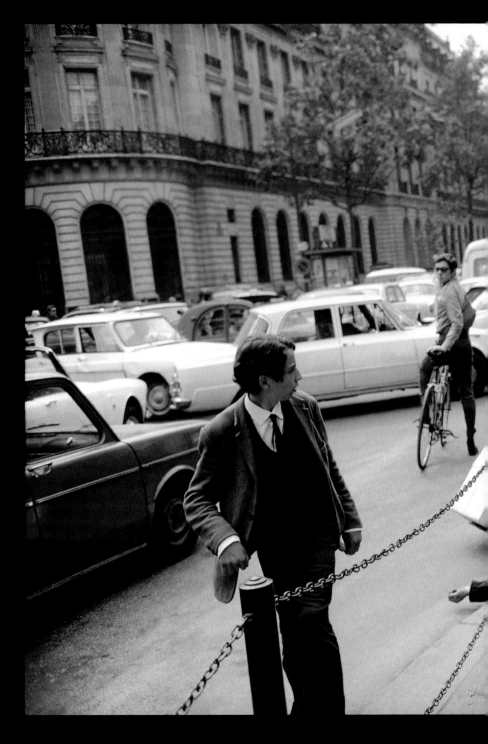

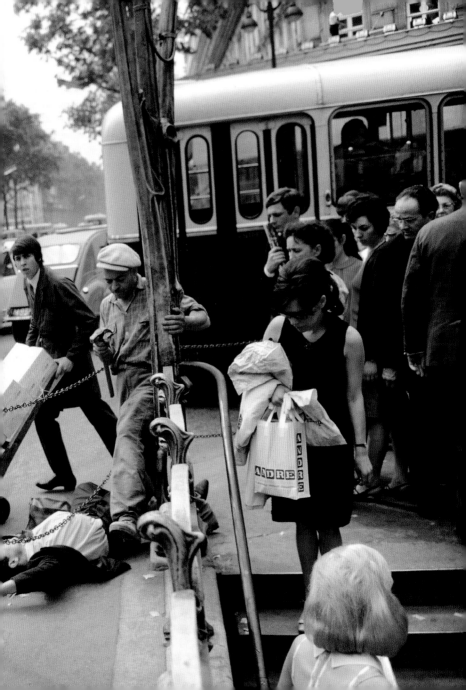

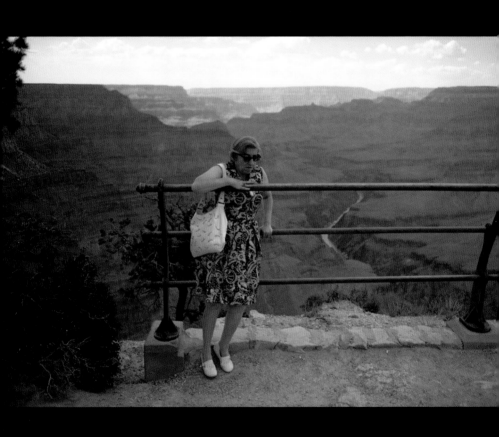

Grand Canyon, Arizona, 1967

Be open to humour

Life can be astonishing, so keep an eye out for funny moments

P eople often ask me, 'How do you make a funny picture?', to which I reply that I don't know how – funny pictures just happen.

Opposite is an example to explain what I mean. I was walking along the edge of the Grand Canyon once when I saw a woman weaving herself into the railings where people aren't supposed to go because they might fall thousands of metres. But this crazy lady with her handbag hanging off her shoulder did it anyway.

The point is that people do the most surprising things, and the witnesses are those of us who carry a camera. We photographers, who have our cameras at the ready, comment on the absurdities of ordinary life – on these crazy happenings that other humans get involved with. And often, you can come up with an incredibly funny picture.

The photograph overleaf (top) is another example. I was in Puerto Rico to shoot an advertising campaign, and while I was walking through a small square, a guy on a unicycle pedalled by. He had flowers and balloons in all colours piled high on his head. As he came past, he adjusted his balance with his arm, as you do on a unicycle, and I noticed his arm stretched out in the same way as the statue's arm. It all happened in a split second – the instantaneous connection between those two elements, the man and the statue – and then it was gone.

Overleaf (left) is another picture that could be funny or not, depending on your point of view. Walking down a street in Greenwich Village in Manhattan, I see a guy in front of a window suddenly decide to drop his trousers, adjust his G-string and pose – to see how good he looks in the reflection. Right near him on the street, another guy seems to be saying, 'What?'

It's that kind of combination and my astonishment that makes a humorous photograph. But there's more. Looking carefully (and this comes from being a New Yorker and living with people of all races, religions, colours and beliefs), in the background I see the sign that says 'Li-Lac Chocolates'. So I'm looking at that guy's backside and immediately I put it together with the sign, and all I can think about is how fortunate I am that these connections came up in a picture.

When you carry a camera with you all the time, it is like an invitation for surprises to happen.

'We photographers, who have our cameras at the ready, comment on the absurdities of ordinary life... and often you can come up with an incredibly funny picture.'

Opposite top: San Juan, Puerto Rico, 1974
Opposite bottom: Paris, France, 1976

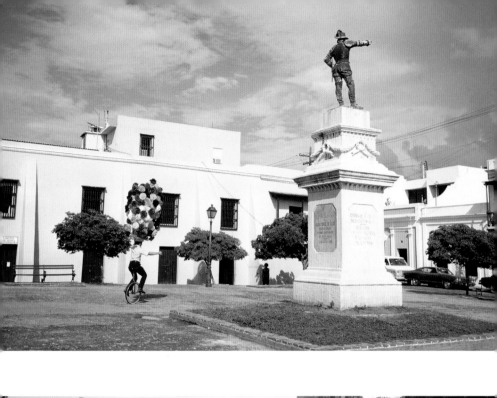

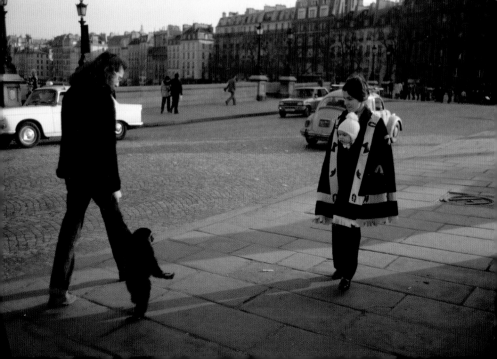

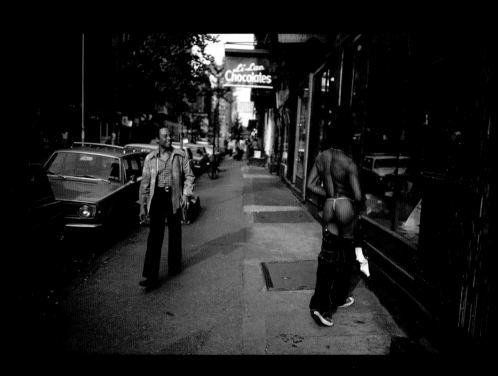

New York City, 1974

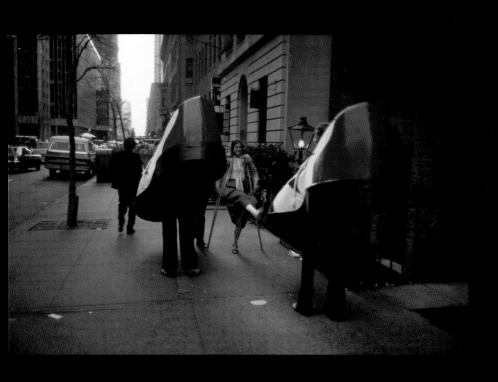

New York City, 1978

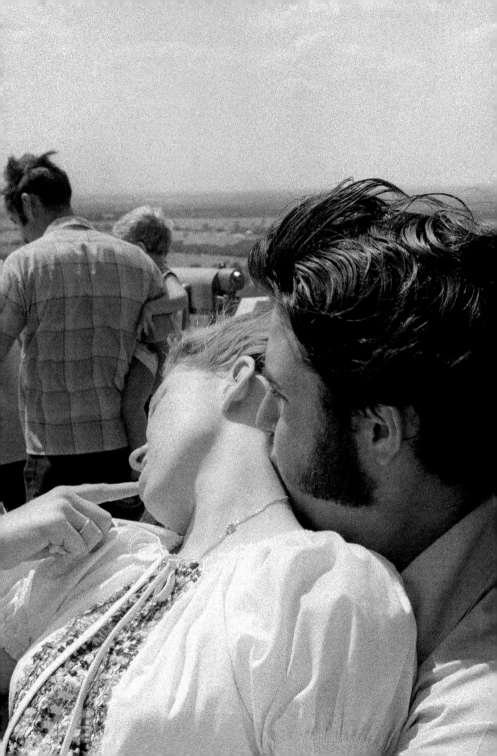

Look for the detail and get in close

Sometimes the smallest gestures or happenings have the greatest impact

The way I see it, photography is like putting a key in a door, opening it, and seeing the world suddenly come alive. And that can happen anywhere, at any time. It doesn't even have to have anything to do with a person. It could be that you're standing in front of a building and you notice the way a crack zigzags down one of the walls. In that zigzag you see a plant growing and you think, 'Oh my, nature – even in the city – has found its way into this tiny crack.' Your attention is awakened by this detail and by billions of other details all around.

I think of this process of being drawn to details as a way of getting excited, of being alive in the world. I channel the energy from those moments into finding out what else there is to see. I do it when I need to get myself started, because it always makes for an interesting photograph and leads to a sense of accomplishment.

The trick is to train your eye to notice details amid the comings and goings of daily life. Look at this photograph overleaf (right) made in Siena in Italy, for example. I was at a kind of cross-roads, with people coming and going from every side. I love to stand at intersections. The mix of people and energy helps me to be invisible, to melt into the crowd, but also brings me new information all the time so that I keep seeing new people and unexpected combinations, all of which offer new photographic

Opposite: Texas, 1971 (detail)

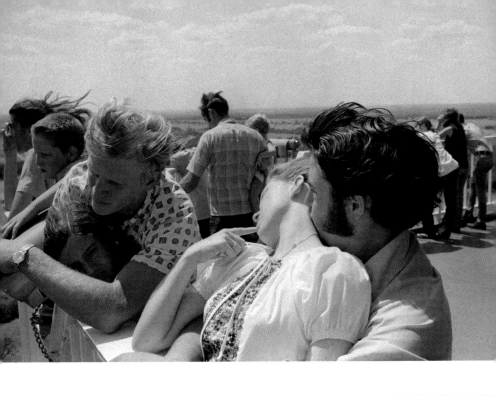

possibilities. I saw a girl talking on her mobile phone, but she also had her water bottle against her mouth. Together the two make a strange picture.

I'm always looking for the light, too. If I spot a beautiful patch of light, I'll wait for people to walk through it. For a moment they're brightly lit and sparks are flying.

So, sometimes in the big mix that is the crowd, there's a human detail – a child crying, someone carrying a huge box – that makes you pay attention. In ordinary life everything seems to be going on in the normal way, but if you look closely, there is fatigue and unhappiness as well as joy and laughter. Intimate things happen in public all the time. Kisses, caresses, parenting highs and lows; it's all there right in front of us, in the public realm. All we have to do is be willing to look harder at whatever interests us, and get closer.

Being attentive to one thing often enables you to see other things, and then include them in your photograph. As soon as you notice a detail of, let's say, a child holding her mother's hand, the next thing you see, right over there, is a guy with two poodles, up on their hind legs, hoping for a biscuit.

If you look at the whole, you will see details that pull everything together. So when you see a small detail that catches your attention, think about how you might be able to use a series of these small things to build a larger picture.

You can't expect to have a great event fall from the sky in front of you every time you go out with your camera. Building on the little events and putting things together that don't belong is how you make interesting photographs and tune up your intelligence and timing on the street.

Above: Siena, Italy, 2017
Opposite top: Texas, 1971
Opposite bottom: New York City, 1964

Look for the detail and get in close 63

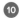

Engage your head as well as your heart

Don't just look, reflect on what you're seeing and keep exploring

Making pictures on the street is a process driven by impulse, but that doesn't mean you shouldn't engage your head as well as your heart. Judgement comes into play too: you have to think about what you're seeing in order to unlock its photographic potential.

Try this. Stand for 15 minutes on a street corner, taking in everything that's going on around you. It's important to try and articulate what you're seeing – to say to yourself something like, 'There's a hot-dog stand over there with great light on it, I should move closer' or, 'There are people crossing the street this way, I should change position' or, 'There are two guys coming, one of whom is in a red shirt, and there is a girl in a red cape and hat'. Then the street will come alive, both in reality and in your understanding of its photographic potential. Something will come up that's intended just for you and that makes sense just to you.

During the filming for the Masters of Photography course, I was walking in a small Italian town and stopped to look at a sunny yellow wall that had caught my attention. I stopped because I found it to be momentarily beautiful. But for some reason it looked like everything I've ever seen before, and I couldn't find a way to make it really interesting. I asked myself, 'Why this wall, how can I push this? Can I make it more interesting?' If you find yourself in a similar situation, take a closer look,

because the thing that will make the picture may not reveal itself straight-away. Also bear in mind that sometimes, inevitably, you will come to a dead end, both metaphorically and literally.

On this occasion, the first thing I saw when I went closer was a detail: a grey square on the yellow background with all these drip marks, layers and textures. Even though it was an insignificant note, it was the only thing at that moment, in that town, that called out to me. Photography, I believe, is all about going further, to see if anything else happens. You never know, but the next thing might be another little gift. So I didn't leave it at that; I carried on exploring the scene.

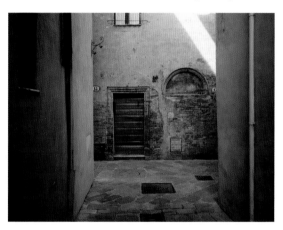

The street had fallen into shadow, apart from one corner, where there was a bar of light. As I came toward it, the space opened up. It was a simple space with a door that had a funny kind of step-like graphic quality, but in fact it was flat. Next to it was a small arch and all these beautiful things on the ground – metal grates, flagstones and so on. Suddenly this little, unassuming place had a kind of theatrical power. From farther away, I didn't see this, but by entering the space I discovered a picture (above) – an assembly of forms.

This simple space became more complex and interesting the longer I studied it, but it is all very subtle. I couldn't have imagined this when I stood farther away; I only saw the sunlight on the yellow wall.

When something says, 'Come to me', go, because you might just find something to work with that allows you to challenge your inventiveness. It's just another way of sharpening your photographic skill.

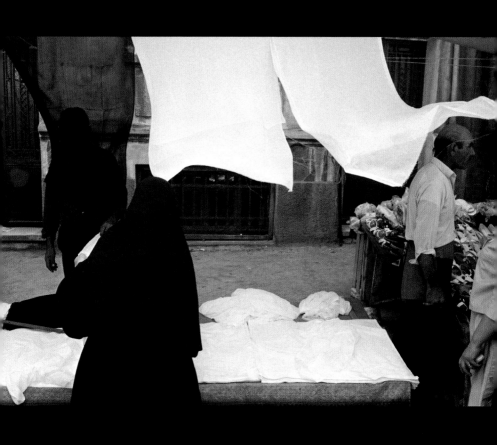

Opposite: Tuscany, Italy, 2017
Above: Turkey, 1967

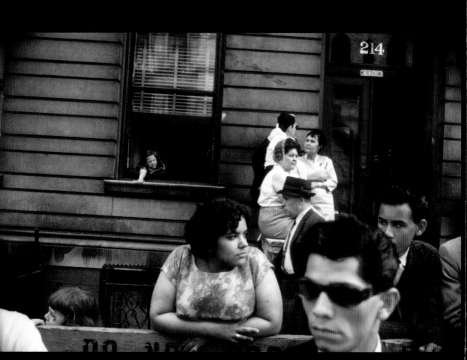

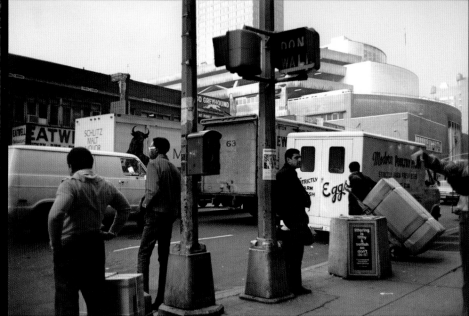

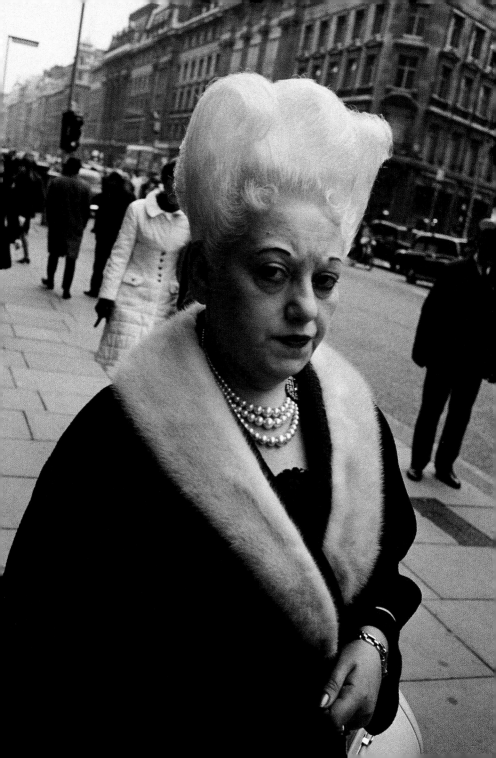

Body language and communication

Where to put yourself, and what to do if someone approaches you

Many times I've been on the street and thought: 'If only that person would go to my left or right, it would make the picture. How can I get them over there?' As soon as you put your body in someone's path, even just a couple of metres away, the other person, especially on a busy city street, will have an internal and automatic bodily reaction – they will most likely instinctively try to avoid you – because they're on the street too, and city people don't like to bump into anybody. People are constantly navigating their environment to avoid contact. I have learned, through instinct, to slip into a person's line of movement without confronting them directly.

The question is, how should you behave when moving through this kind of environment? Usually I'll try to melt into the crowd and become invisible but sometimes, if the moment calls for it, I may talk to people, because it's fun.

If somebody stops you and asks what you're doing, it's the right moment to be charming, so you might say, 'The fabric of your shirt/jacket/dress is beautiful, I just had to take a picture of it' or, 'You look great, your tan is so gorgeous, is it OK if I take a picture?' You'll figure it out when you're in that situation.

If you are affable, honest, friendly and respectful, people will probably say, 'Sure, of course', because you seem innocent and genuinely interested in them. They may even strike up a conversation.

Opposite: London, England, 1966

'You know, I just came back from Jamaica…' And so the conversation develops. 'You're really interesting', you might remark. 'May I make a portrait of you?'

See, it's a trick, and I mean this in the nicest possible way. But let's face it, you learn that trick – getting a person to be on your side – and you use that trick, which is all about being nice to people, and complimentary. Nobody will think you are aggressive if they're not threatened by you. And you're not a threat – you're not acting in a threatening way, you're simply interested in making a photograph.

I think of myself as a kind and gentle person, but I use these tactics on the street because compliments go a long way. So, go out there, follow the light and learn to get close to people. Your life as a photographer will be richer for it.

Top: World's Fair, New York City, 1964
Centre: Indianapolis, Indiana, 1965
Bottom: Wyoming, 1964
Opposite top: Chuckie, Provincetown, Massachusetts, 1980
Opposite bottom: New York City, 1974

Visual play

Play with what you're seeing

Photography is a tool that enables us to go out into the world and find bits and pieces, moments and objects, people and places, time and light, the sea and the mountains. Almost everything is photographable. All you have to have is the interest and the appetite.

The 'game of seeing' can be played anywhere, and in that regard photography is very generous. It is about discovery and surprise, and the fleeting instant when something reveals itself to you. The more you open yourself up, the more you see.

Overleaf (left) is a good example. I was walking down the street in Mexico once and as I turned the corner I saw a boy lying on the ground with a stick he had made into a sword. He was lying down with what could be a crucifix, which for me created a momentary parallel to religious paintings and the epiphanies and visions that those works describe.

It was a completely innocent moment, just a child lying on the ground with his sword. But the reading of a photograph is fluid. Part of photography's power and magic is that there are many ways of interpreting the same thing. There is often a degree of ambiguity. The camera describes everything that's in the frame, and yet we're uncertain about the meaning of any image. It is in that subtle and ambiguous space that photography gains its

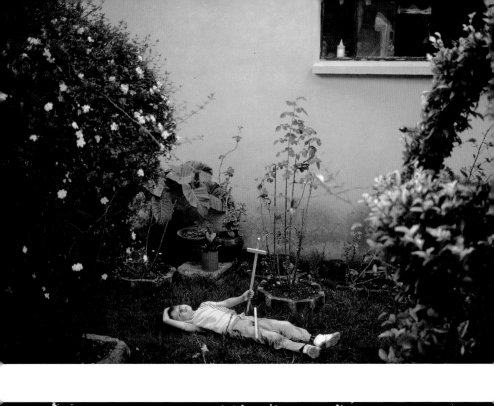

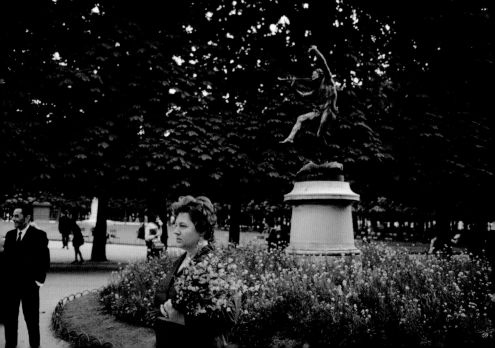

power. Something may look like one thing in reality, but it may mean something else when you look at it later on a screen or as a print in your hands.

Artists play, but in a serious and often emotional way, and when you play with your mind wide open you'll find things that will speak to you and create your kind of vision.

Here is another example – overleaf are four photographs of a very simple subject, a bay and the sky with a horizon line in the middle. I made these when I was living in Provincetown, Cape Cod, right on the water. Every day I saw the same view but every single day was different. No matter how constant the horizon line was, I saw weather systems, changes of light, a slow shift in the seasons and winds and storms sweeping through.

I found myself making a record of the beauty of a single place, which got more and more interesting as I began to see more. It's almost as if, after the first two or three pictures, you strip away some of the blindness you have about making this kind of picture, and you get into the rhythm, the cycle of seasons and weather of the place where you're spending time. That familiarity gives you a confidence that allows you to explore it more deeply and can lead to images that are surprisingly diverse.

I thought of the pictures I was making as those samples you get when you go to a paint store. You might pick out a blue, and a blue-grey and a blue-grey that has a greenish tinge, or a blue-grey with a little lavender in it. You keep finding the subtle changes in these tones. I thought of my photographs as paint samples that nature was developing just for me! By doing so I learned something about the colour vocabulary of film and light, and my own interests. Part of the joy of photography is that it's always giving us lessons; even if we think we know it all, we get taken by surprise – 'How did I miss that?'

Use photography as a lever to lift the weight that you sometimes place on your own work, because we all get in our own way. Photography holds the secret of how to get out of the corners we paint ourselves into.

Opposite top: San Cristobal de las Casas, Mexico, 1971
Opposite bottom: Paris, France, 1967
Overleaf left: Bay/Sky, Provincetown, Massachusetts, 1984

Overleaf right (top): Bay/Sky, Provincetown, Massachusetts, 1984
Overleaf right (bottom): Bay/Sky, Provincetown, Massachusetts, 1977

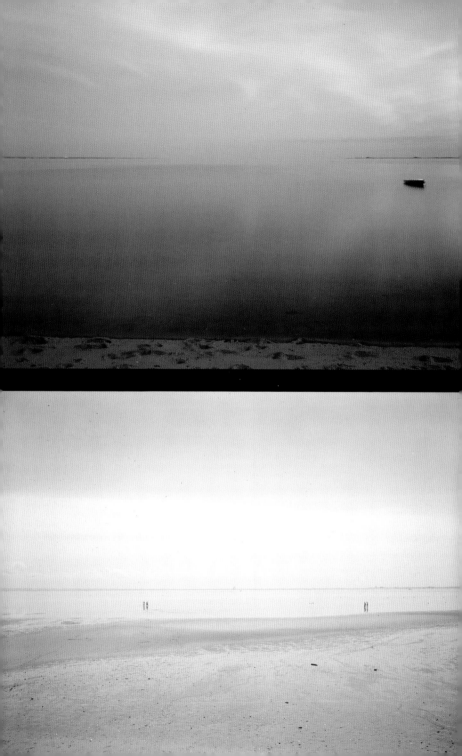

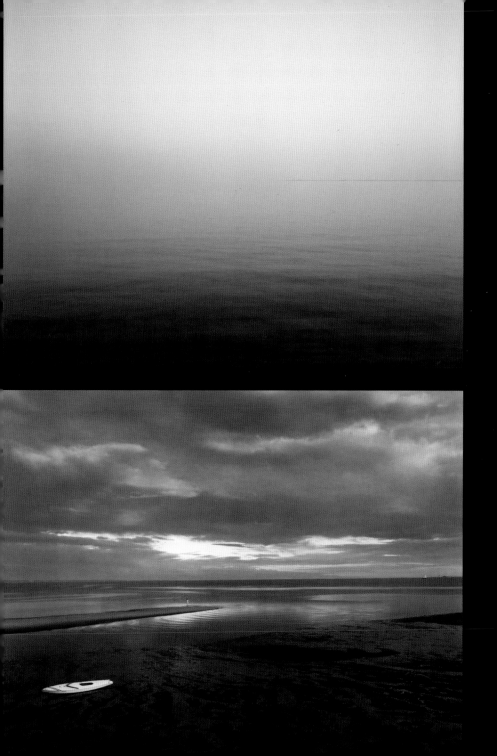

Be at one with your camera

Gear isn't everything, but use a camera and lens that feel right

I've never cared too much about the technical side of photography. I mean, I know how to use a camera to make a correct exposure, but I don't get too caught up with photographic technique. More importantly, I know the lens that gives me my best relationship to the way I need to see the world, and that, I think, is an important thing for you to consider too.

So, what's your lens? It all depends on what you see and how you want to describe it. Do you see the world up close? That's a telephoto, or, for real close, a macro. Do you see a deeper space and wider view of the world? That's a wide angle.

As with everything we're talking about in this book, all photography is about you. What's your personality? Do you want to compress space and flatten everything? Use a telephoto. Do you want to bring things that are far away near? Again, use a telephoto. If you want to plunge into the stream that is the street, if you want to swim in there like a fish moving through the crowd, you need a lens that matches your vision of the life of the street. Use a 35mm.

Think about this for a moment. How do we see, as humans? What is human vision? What do we see normally? If I look straight ahead I can sense, without moving my eyes, my wiggling fingers at the side of my head. That's 180 degrees. But I can't look at my fingers unless I turn my head.

Our normal vision, when we're looking straight ahead, is somewhere between 60 and 70 degrees, and a 35mm lens comes closest to matching that span. So if you're interested in photographing the world around you as you enter it and as you perceive it, use a 35mm lens and forget about zooming in and out all the time. A 35mm lens is what I call a one-to-one lens: what you see is what you get. Since photography is really about refining your identity, it will enable you to see and even anticipate the things that you find interesting because it will strengthen your 'reading' of the space in front of you. And that will make you more alert to the potential hidden in ordinary moments.

'I've never cared too much about the technical side of photography. I mean, I know how to use a camera to make a correct exposure but I don't get too caught up with photographic technique.'

So my most important technical advice is to find a lens that suits your personality. Of course, you may have more than one side to your character – maybe there is also a telephoto in your future. But whichever lens you choose, master its qualities and stick with it. Don't keep changing lenses all day long; it can break your concentration and rhythm, particularly when you are starting out and need to learn just what the world is saying to you. You don't want anything to distract you from your own self-discovery.

In truth, sticking with a single prime lens is a test of your discipline. It means you've got to make the picture by physically moving closer to or farther away from what you're photographing.

Trust me on this. Pick a lens that feels right, and if it makes you feel frustrated, change it. That happened to me when I was a young photographer. The camera I borrowed before I got my own had a 50mm lens, but I couldn't stand it. After a week, I felt so frustrated that I had to get a wider lens. I bought a 35mm lens and my life changed – I was finally getting on film everything I was seeing on the street.

New York City, 1975

The middle isn't always best

Shift the focus of your picture away from the centre

Most photographers put their subject in the middle of the frame. It's easy that way, right? It's like shooting an arrow into a target. When I was a young photographer I did that a lot because I wanted to capture the moment or the look, the gesture, the expression, the beauty and so on. It was a case of 'Look, there's an interesting subject, gotta get that picture!' Bang! Right in the centre. And this is OK because whatever it takes to make the photograph, you do it.

But after a while you'll begin to notice that most of your images are centred, and you may start to see a sameness in your work.

To make a photograph where the focus isn't just on the centre doesn't come right away; it's something you have to learn. I certainly had to. I learned that it is possible to sense the need and then spread the energy of the moment over the entire frame, because the truth is, as you become more sensitive to the way photography works, and to your own instincts, you will enlarge your emotional and visual capacity, and that will allow you to see your world in a richer, more complex way.

If you make the picture interesting enough, any person who looks at it will read across the frame – from the centre to the upper corner and down the side, for example, rather than just looking at the thing in the centre. They will follow the tune that you're playing inside the photograph. You *show* people how to see by the images

you make, and, better yet, you show them how wide-ranging your vision is when you record the world around you.

It's possible to make pictures that are more complex. Take this one opposite (bottom), for example, which I must have made about ten years after I began my life as a photographer. I was alert and finally conscious enough at that point not only to use my position to disperse the energy away from the centre, but also to know how to see the many simultaneous moments that can build and enrich a photograph.

'As you become more sensitive to the way photography works, and to your own instincts, you will enlarge your emotional and visual capacity, and that will allow you to see your world in a richer, more complex way.'

There's the tiger in the window. There's the blind guy with his dog. There are several women whose feet are lined up in the picture. There's a guy with a briefcase entering the sunlight from a shadowed area. And then there's the sky and the flags and the buildings, all of it making a 'deep space' photograph. I was able to *see* and to *know* what was happening, and to embrace everything on the street, while trying to describe the overall sensation of what it was like to be alive in 1975 on the streets of Midtown Manhattan. At that time I was learning how to give up what I had learned to do well – which was to make a kind of athletic catch of a moment – and to move away from the traditional Cartier-Bresson 'Decisive Moment' kind of image. I did that by trying to take on the crazy energy of modern, urban street life and make what I then called 'field photographs' – pictures about everything in the field in front of me. But first I had to *know that I needed to do that to grow as an artist!*

Opposite top: Florida, 1967
Opposite bottom: New York City, 1975

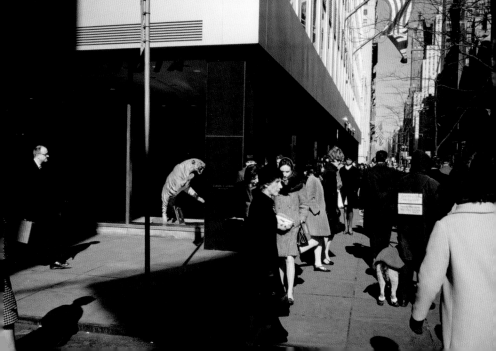

New York City, 1970

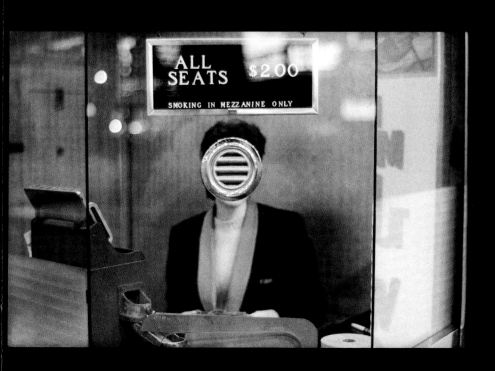

New York City, 1963

Notes on composition

A few ideas to inspire and try

Composition, as we started to discuss in the previous chapter, is really anything you want to make of it. You've got a frame, which you're going to fill with the things that appeal to you. So what's important in the frame? What should you include? What should you leave out?

If you look at what's around an object and not just at the object itself, you can find interesting combinations. So stay alert and build up what's in the frame. You don't want to just take a picture; you want to make the photograph. And that's where your photographic intelligence comes in. When you bring things together in the frame, you're making art.

Let's consider a few images. Take the example opposite. While on location in New York shooting one of my Masters of Photography tutorials, I made a portrait of a woman, and above her head was a hand, which was a similar colour to her hair, clothing and lipstick. There really wasn't much going on at the time, but we were filming, so I had to work with whatever came up. When I saw the colour of the illuminated hand and the colour of her hair, I reacted to the combination – a quick observation, but also an environmental portrait.

You have to think like that when you're on the street – about how it might be possible to put together combinations, sometimes from the tiniest of moments.

Opposite: New York City, 2017

One way to establish a sense of what's important in a frame is to create a picture within a picture. Below is a photograph that's basically about a frame within a frame. There is a doorway in a building with another door in it, and I put the frame around it. As I walked by this building, what I found so interesting – what I first noticed – was a little square of blue (which was the sea), the sunlight on the sand, the quality of the sky, and this little cloud. I was struck by how the sea looked like a square, and the square was inside the rectangle of the door, and the door was inside the rectangle of the building, and the whole building was inside the rectangle of my camera.

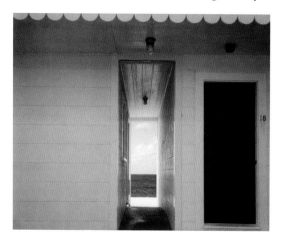

I thought this was a very interesting way of entering the frame and going out the other side into the sunlight. And so the call to make this picture came in a very direct and persuasive manner. I stood there and made the photograph, then carried on going about my business.

Photographs should invite us in. You want the viewer to look at your photograph and enter into the moment to which you responded so fully, because those are poetic moments – moments when your consciousness is so excited by where you are that you enter the space and record it in its entirety.

Another way of considering composition or space is to think about the beautiful chaos we see in the world. I remember, many years ago, walking past a chain-link fence in the countryside. Behind the fence was a big hairy guy with his shirt off, using an emergency public telephone hung on a telephone pole. His head was blocked by the phone box cover, so all I saw was a hairy body belonging to a big guy and then layers of chain-link fencing with shadows coming through. The whole scene looked as though somebody had taken a photograph of a man and then erased or crossed out parts of it. The picture

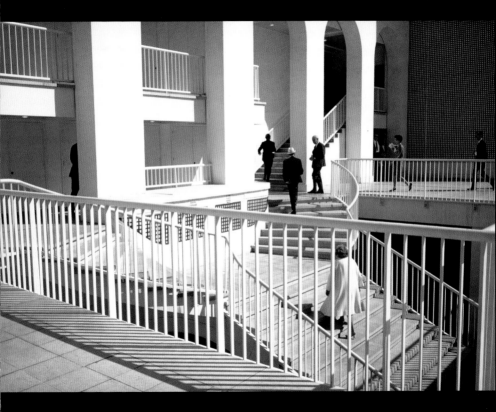

below is really about complexity, about how difficult it can be to see just what is going on, but it is also slightly surreal, and I responded to the two ideas immediately.

When I showed the picture to John Szarkowski, who at the time was the head of the Museum of Modern Art's photography department, he said he wanted to include it in an exhibition. So there I was, a young photographer, and I had made a 'risky' and uncertain photograph. Yet someone who knew about photography thought it was interesting enough to hang in an exhibition. You never know what chaos, and your recognition of it, will bring to you.

Opposite is another photograph that, in a way, is about the beauty of chaos. I was doing some commissioned work in St. Louis many years ago, and walking down the street I saw these old buildings. The rest of the neighbourhood had fallen into disrepair, but these three houses seemed to be clinging to each other. I was amazed by how tender and tragic they were; the neighbourhood was falling apart, but they were still together.

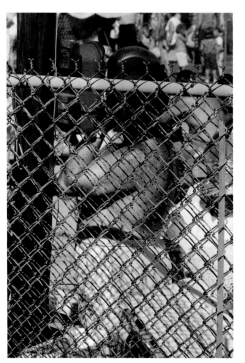

There were some trees in front of the buildings, and as I looked I thought, 'These trees are like a screen over the buildings. I'm going to add them to the picture rather than walk around and find the position where there are no trees in front of them'. So I added them as a layer of density, a layer of complexity. I mean, I could have just walked around and made another picture, but when I saw the result, it felt absolutely right. And that, I think, is the way composing on the fly works. Something appears, you have a gut response, and then your mind comes into play – should I or shouldn't I? When that happens, I think you should.

There is something else I'd like you to add to your arsenal of tactics in terms of composition (and remember, composition is anything you want to make of it). The world offers lots of opportunities, as we have seen, but something to look out for, or that you might want to keep in mind, is what I refer to as 'the frieze'. Let me explain.

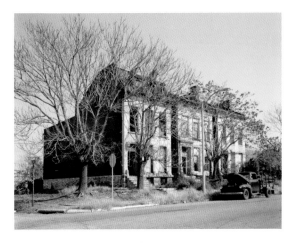

A frieze is typically a decorative panel found toward the top of a building. Usually it's figures in ancient Greek architecture, but a group of people sitting on a bench or walking across the frame of a photograph, for example, could also be called a frieze. The people might be in some kind of alignment whereby you can see the rest of the scene behind them.

You could say to yourself, 'Those people are blocking the shot', or you could say, 'Ah, the people in front *add* a layer of interest to the scene behind'. It's a matter of perspective – how you choose to look at what's in front of you. Remember, photographs are two-dimensional descriptions of three-dimensional space. If you close one eye you take away the third dimension, so you'll see like a camera.

You can do this with people and with the landscape; it doesn't matter. In fact, the frame-within-a-frame conceit, the notion of beautiful chaos, and the frieze are parts of the same puzzle you work with when you walk around in ordinary life. Whether you're in a city or the countryside, whether there are people or not, it's all a game of sight.

Push yourself

*Have courage and reach beyond
your limits*

Sometimes chance provides you with an opportunity to do something bigger than yourself, something outside the scale and scope of your ambitions. It's those moments that drive you toward becoming the artist you can be. And that's the secret of any art form. If you reach beyond what you think are your limits, you'll extend and expand yourself; you'll become the next version of yourself.

This happened to me when I photographed at Ground Zero after 9/11. Even now, I get chills when I think back to the destruction that occurred there. I ended up spending nine months at the site, making pictures day after day. Photographing on the pile was one of the most powerful experiences of my entire life.

When I heard that New York had been attacked, I wanted, as a native New Yorker, to help in some way. In reality, by the time the public was allowed close to the site, all the work of clearing and searching and so on was taken. What could an ordinary citizen like me do?

Then, one day, something happened while I was visiting the area close to Ground Zero. While standing in a crowd near the site I raised my camera just to see what I could see, and a police officer behind me barked, 'Hey, no photographs allowed, buddy, this is a crime scene.' I remember being shocked and thinking, 'Wait a second. The crime scene is in there.' So I said, 'This

is a public space. You can't tell me not to raise my camera. I'm a citizen. I have a right to raise my camera.'

I started arguing with her. 'Suppose I was a member of the press?' I said. 'What then?' She laughed in my face. 'The press, huh? Look over there.' I looked over and saw a dozen video cameras with big booms, and reporters, all behind police tape. I asked her when they were going in and she replied, 'Never.' Mayor Giuliani had declared the site off-limits to photographers. At that moment, a little light bulb lit up in my mind.

It seemed to me that no photography meant no history. How could that be? How could a modern event on this scale go unphotographed because the mayor didn't have the foresight to understand that history had been made on his watch, and that it needed to be recorded? I tried to convince Mayor Giuliani through intermediaries, but he wouldn't listen.

Too bad, I thought. We can make this work. I'm going to figure it out myself. And then it came to me: I realized how I could be useful. All those years spent editing photographs, mine and sometimes other people's, meant I knew my way around an archive - and I knew how to *build* an archive. So I thought I would make an archive of 9/11. After a few days spent reaching out to various people in the government, and others, I was able to get a worker's pass and finally made my way into the site. Unfortunately the cops there were following the mayor's orders, and I was being thrown out four or five times a day. Then, one night I spotted a pile of rubble that looked like a hill. I knew that in order to make the shot I wanted I had to shoot from the top. But when I looked up, there were 11 police officers there, and I knew they would throw me out. I walked up the hill and when I got to where the cops were - they were sitting on chairs that had fallen out of the building - I sat down on somebody's lap and said, in real New Yorkese, 'Hey, you guys are in my spot.'

They all leapt up, saying, 'Wait a second, what are you doing?' I replied, 'I'm the history photographer. I'm making a document about everything here for the Museum of the City of New York.' They all agreed that needed to be done, 'for our kids and for our grandchildren', they said. 'We need this history.' 'But the mayor

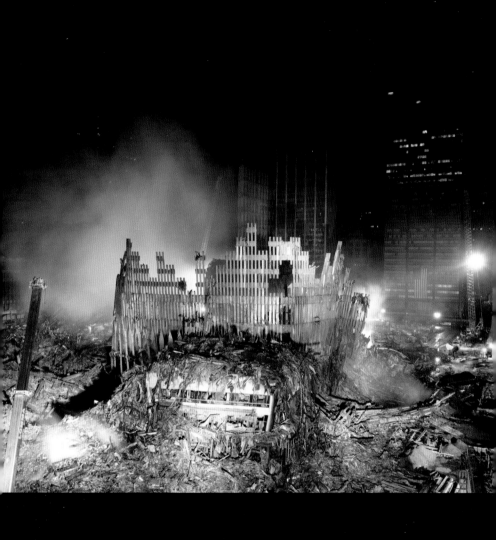

The base of the North Tower, looking
eastward toward the Woolworth
Building, New York City, 2001

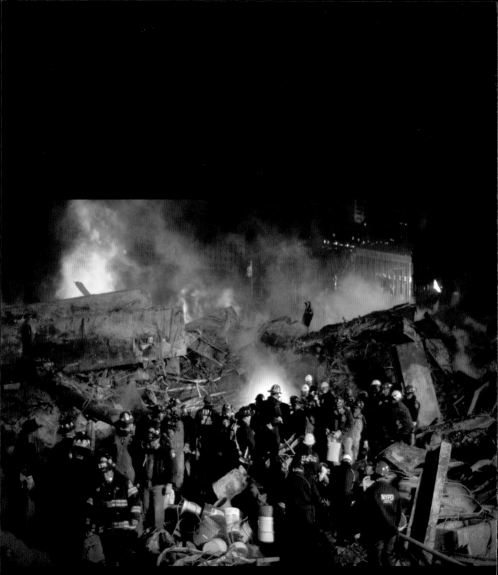

says no photography,' I said, 'and I'm being thrown out every day.' 'Screw the mayor,' was the reply. 'We need this for our history. We're going to protect you.' And from that day on, for the next nine months, those 11 police officers from the NYPD Arson and Explosion Squad took care of me. Any time a cop threw me out, they said, 'He's with us.' Because of those police officers we now have a history of almost 9,000 photographs showing what happened at Ground Zero.

When 9/11 happened, I was 62 years old, but the work I had to do was really meant for a much younger person. I was walking 2½ miles to the site in the morning and 2½ miles back at night, carrying 18kg of equipment without any help. I would spend 10, 12, 14 hours a day inside Ground Zero, walking around and around and around, up and down, in and out, usually adding another 6 to 10 miles a day.

I was walking almost 15 miles a day, carrying all this equipment, in a dangerous place that was full of toxic chemicals and fumes. Parts of it were on fire, and there were often explosions. Brutal shards of metal stuck up everywhere.

I had a kind of passion that consumed me, but remarkably, through doing such demanding work, I felt young again. Photography, and my commitment to what I was doing for the people of New York, made me experience the same thrill I'd had when I started making pictures in 1962 as a 24-year-old. Photography was like food – I had to have it every day. There I was, doing the same thing I'd been doing since I first picked up a camera 40 years earlier: going out and seeing, allowing myself to be carried away.

So think about this. A project comes to you, perhaps something you decide on yourself because you love it – the lake close to where you grew up, the church that you belong to, or a group of interesting people in your neighbourhood, whom you want to make a portrait of. If such a project comes your way and excites you, if you go into it open-heartedly and with all of your energy, you'll find incredible things that will teach you, inspire you, carry you along, and ultimately shape the artist you're capable of being.

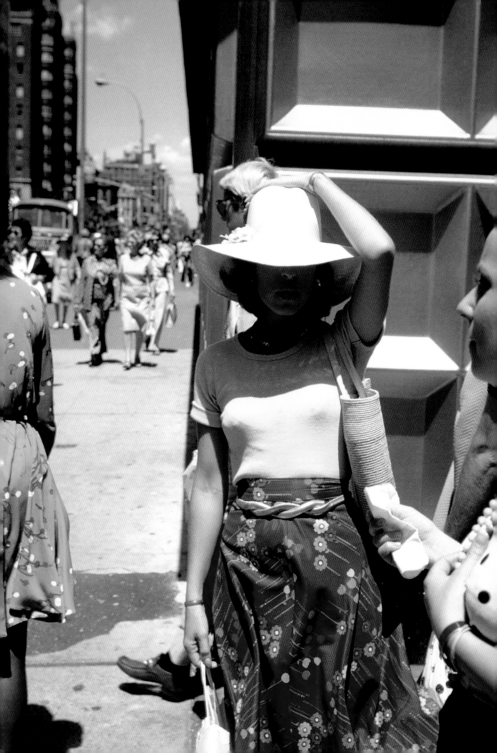

Photography is about ideas

What do you want to say?
Find your subject

I t took time for me to evolve as a photographer, to get to a place where my appetite was bigger, where my ideas about photography became more developed.

This is an important thing to consider. Photography looks like pictures, but it's really about ideas. And they're your ideas; they are unique to you. Only you can realize these ideas when you figure out – technically, emotionally, psychologically and physically – how to put yourself in the right place at the right time to make an interesting picture out of nothing. 'Nothing' in this case is the 'everything' of everyday life. Ordinary life, as we keep seeing, is constantly charging the frame, and you, with new possibilities.

So how do you get there? It's up to you. I can tell you that these things are possible, but you have to go out and do the work yourself. My hope is that by sharing my own experiences I can help you to figure out and get closer to the things you really care about.

What do *you* want to say? Everybody makes photographs in a general sort of way in the beginning, and then, after a while, there comes a kind of itchiness. You might find yourself asking: how do I bring my pictures together? How do I find a subject I can really concentrate on, dig into deeply? I've been asked this last question a lot over the years. Do we determine the subject, or does a subject that already exists find and define us, wake us up?

Opposite: New York City, 1974 (detail)

Each of you must answer for yourself, but it may happen like this. You look at your contact sheets or computer screen and begin to see that every day, amid all the pictures you've taken, there is a certain kind of picture that you always seem to have responded to; let's say mothers and children, or couples with dogs, or people with red hair. It's almost as though your subject is already there, staring you in the face, but you've been overlooking it and you just couldn't see it until now.

So, taking the time regularly to really study the images you're making is a valuable thing to do. When you look at your selections you might just discover the essence of what you're truly interested in, and that will raise your awareness. You'll then think, 'Right, I'm going to keep my eyes open for mothers and daughters', or whatever the subject might be.

'It took time for me to evolve as a photographer, to get to a place where my appetite was bigger, where my ideas about photography became more developed.'

I'll tell you what happened to me once, because it might be useful. I was editing work on a light box and had hundreds of slides out. I was looking for a selection of images while trying to solve a problem for an advertising agency. As I was going through, I noticed a funny slide of somebody with flowers, and then I noticed another picture of someone else with flowers – this person was wearing the flowers, rather than holding them – and in another image my subject was standing in flowers.

After a while I had three or four of these pictures on the light box, and asked myself, 'Do I photograph flowers?' It's funny, because the flower as a subject is a real cliché, so how could I beat that cliché at its own game? I decided that while I was editing those pictures, I would keep an eye out for anything with a flower in it, whether it was on a curtain or a person carrying a bunch of flowers.

By the end of the edit, I had 50 or 60 pictures featuring a flower or flowers in some unexpected way, so I decided to go through my whole archive and locate every image containing a flower.

Opposite top: Vivian, Bronx Botanical Gardens, New York City, 1966
Opposite bottom: New York City, 1976

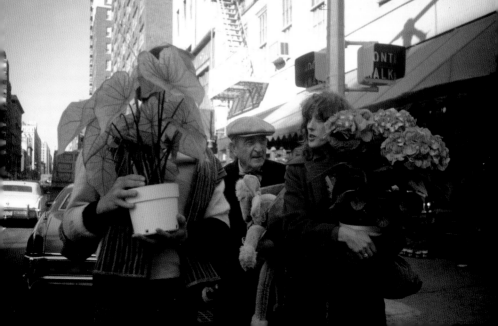

It turned out I had hundreds of these photographs, and I thought, 'I'm going to make a book out of this.' But before I did that, I thought it might be interesting to add to the collection of images.

Any time I was photographing on the street, I looked out for potential flower pictures; and whenever I saw something with a flower in it, on it, being carried, stepped on, in the background, foreground, or even a cloud that looked like a flower, I would make a picture and add it to my collection.

Eventually, I had hundreds and hundreds of these photographs and I was able to make a book, *Wild Flowers* (1983), spanning all genres. There were portraits, landscapes, interiors, still lifes and even nudes. Every conceivable way a flower could appear became part of my book.

This was a subject that popped up for me out of the editing process. So if you are searching for something new, take a journey into your own interests first. Look at the work you already have and see what it is you've hit on again and again and again. Your subject has identified itself already; it's just that you may not have recognized it yet, and that's your responsibility.

Once you name that subject for yourself, others will come to you because you're now more aware and you've reflected. You are full of subjects; you just have to let them come up and carry you away on a journey.

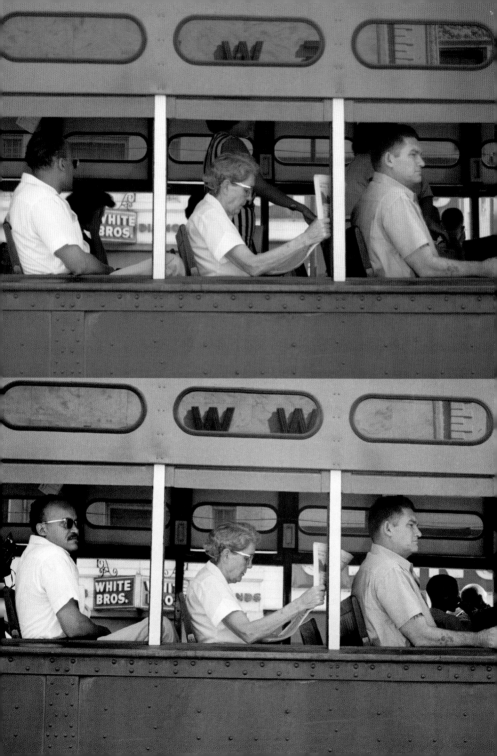

Colour or black and white?

Choose the approach that best suits your subject

When I started making pictures, in 1962, black and white was considered the 'high art form' of photography, but I didn't know that at the time. I had been a painter and an art director, and when I discovered photography the first thing I did was load my borrowed camera with colour film. Why? Because I thought, since the world was in colour, why wouldn't I want to be photographing in colour? Only later did I feel the resistance of the fine-art world to colour photography; it was thought to be too commercial or only suitable for weddings and family snapshots.

It's hard to believe today, but back then colour photography was considered gaudy and cheap. Perhaps, at best, it could be used for reportage by some magazines. But I saw it as an incredible description of the world I was living in, and I wanted to free the idea of colour photography from the restrictions the art world was placing on it. So I did something very personal.

I had two Leica cameras, and I loaded one with Kodachrome colour film and the other with Tri-X black-and-white film. I walked around with both cameras, and whenever something happened that was interesting but unfolding slowly enough, I would make one shot in colour and immediately afterward, a second shot in black and white. One film took the colour out of the world and left it as a graphic solution to a photographic

Opposite: New Orleans, 1963

problem, while the other kept the colour and added an emotional and spatial depth to the photograph.

I put the photographs together in pairs so that I could study them and learn how each described the world. In this way I understood the power that colour had for me, and from then on I tried to make a convincing argument to everyone I knew about the value of colour photography.

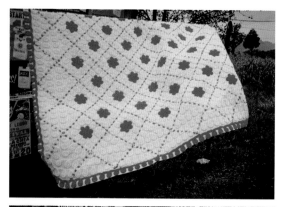

I have hundreds of these picture combinations; let me tell you what I did.

Once, while I was travelling in the American South, I saw a quilt blowing in the wind. I made a photograph of it in colour and then another in black and white (left). The black-and-white one appears to show black florets on a white field, but when you look at the colour one you realize the florets are red on a white field, and all the lines and the border are red too. Beneath the blanket are the green tones of the grass, and in the background a storm is coming. The sky is blue-grey, and there are signs for a travelling circus in yellow and red.

Suddenly, this simple photograph is full of notes of colour. It becomes a much richer experience, both in reality and later on in the print. I had to make that kind of distinction early on in order to commit myself to seeing in black and white or colour. Nowadays, these things can be changed easily enough in post-production, in Photoshop, but when you choose your media, you should always have a reason why you're using one or the other.

Ask yourself what it is you mean to say. If the graphic world is important to you, choose black and white. It is your responsibility to do what is right for you and to do it open-heartedly, so that everything you see is shaped by your belief that black and white and all shades of grey in between will allow you to render objects in space and time and light in a way that pleases you. If colour is what gets you, open yourself up to that and see how complex, rich, and interesting shooting in colour can be.

It's almost as though these are two languages that communicate their messages with different visuals. If you look at it that way, I'm sure you will have the same kind of playful responses that I did, and, above all, you will be inspired to think and see and feel in both colour and black and white – and be able to switch between the two when you see the need.

Thinking about how you want to make photographs is to think about how you are in the world. It lifts you up a level; you're not just another person with a camera wandering around wondering what to do. You're solving problems photographically and in interesting ways. Anything we do with passion, obsession or desire teaches us not only about the medium we're using but about ourselves.

We are fortunate to be living in a time when digital cameras have exquisite metering systems, especially for colour. That said, if you're in a landscape where there is a lot of bright sky, for example, you might find that the camera reads the light and overcompensates for the bright sky and your picture is darker in areas where you'd like it to be lighter. This may mean that you have to make some adjustments afterward in Photoshop or Camera Raw to get the exposure you know is right.

I have developed a system – a little like Ansel Adams's zone system, only it's the 'Joel Meyerowitz colour-zone system' – which can help you to make more balanced exposures and be free from anxiety when you are out shooting.

It involves setting your camera to a particular shutter speed first; I almost always use 1/250th of a second. That way you need only adjust the f-stop as you move from shadow to sunlight. You can work for about an hour in this manner (if you are staying in the same place) and get very consistent, solid exposures. Let me explain.

When Kodak first manufactured colour film, they tried to build a film that could hold on to the most information in the darkest shadows while also holding all the detail in the brightest highlights. Back then they balanced their films for white skin colour.

'I saw colour photography as an incredible description of the world I was living in, and I wanted to free it from the restrictions the art world was placing on it.'

The mid-tone, that place between the shadow and the highlight, had to be a point that allowed white skin to look 'right' in all light conditions. For that they determined that the mid-tone was the equal of what they called a grey card, an 18 per cent grey, because that amount of grey is equivalent to pinkish-coloured skin. This was important, because if you got the skin tone right all other colours in the photograph would be in relative balance.

The grey card, which was sometimes placed in a scene and often had colour bars on it to enable technicians or professional photographers to know that their exposures were on the mark. Of course, that was before digital, but the principles remain relevant today.

If you were to photograph the grey card and your hand in sunlight, in black and white, both would be close to the same grey value. Most important of all is the fact that when the skin tone is correctly exposed, all the other colours and values in the visual world around you are in balance to that value. That's how colour film was designed to work, and the result is a beautifully exposed frame, every time, for every subject.

If you were outside on a sunny day and looked at people coming toward you, you would see a highlight on one side of their face and a shadow on the other. Under those conditions the right exposure for a photograph is one that holds the details in the skin tones in the highlights and keeps the shadows open enough that the faces are neither too dark nor too light. If you could find the midpoint between the highlight and the shadow you would make a perfectly balanced exposure. It's tricky to do that when the camera is on auto exposure, since the sensor is always readjusting

to every nuance of dark or light as you shift the camera around. You've probably seen the way the screen shows the variations from light to dark as you move the camera. Wouldn't it be nice to have a sense of security that would free you up to just shoot, to know that your exposures would be consistent?

I'm happy to share a simple idea I've been using for more than 50 years. Since it's the skin you want to measure in terms of getting the right exposure, you need to make the camera's metre read the light that is falling on the faces of all the people you are photographing. Look at someone's face that is half in sunlight, half in shadow, and allow the camera to measure the midpoint between the highlight and the shadow, adjusting until the little red dot is perfect. Then you will have the right exposure for everything in the frame.

If you want to give it a go, here's how to do it.

Look at the scene in front of you. Extend your arm and hand in that direction, cupping your hand slightly so that it imitates the light falling on a face (your palm is concave while a face is convex, but that doesn't matter; what matters is that you imitate the *feeling* of a face in sunlight). Tilt your palm down, just a little, because if you look at a face you'll see that there are shadows beneath the brow and under the nose and the chin, as well, of course, as the shadow on one side of the face. Then, holding the camera in the other hand, read what the camera's metre says is the right combination of speed and f-stop for the ASA/ISO you are set to. Put the camera on manual, set it to those numbers, and go for it.

Try to remember the settings so that any time you enter that kind of light space, you'll know what numbers to use.

You could just use the camera's metering system and make adjustments in post-production, but if you want consistent results, and if you want to think like a photographer, make this a lesson for yourself and remember it.

So, go outside, learn to look carefully at the light, read the light, and calculate the exposure. With time and practice you'll get better, and before you know it you'll have a useful new tool at your disposal.

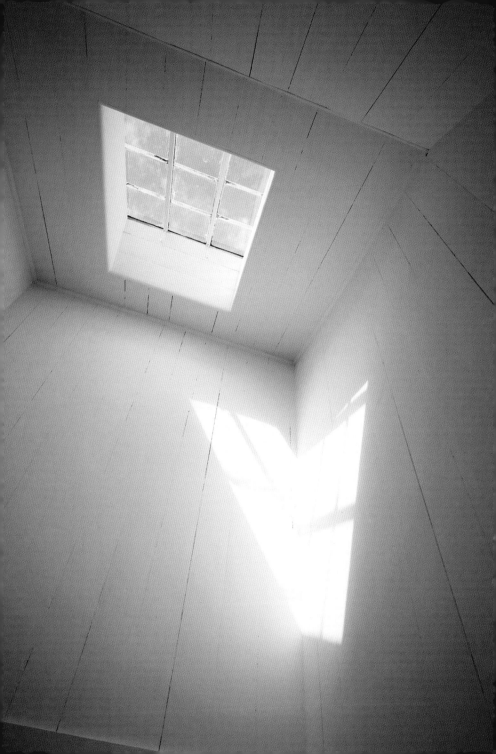

Light as subject

Drawing inspiration from light and shadow

Observation. Really, that's what we do as photographers. We're observers. We're like a telescope looking at the world. Our observations give us an appetite, subjects, direction. Observation is the guiding force behind making photographs. It is not enough simply to observe, however; what matters is the *quality* of your observations. It's all about being attentive and aware, and opening up your mind so that you see the light everywhere that you photograph.

Say you enter a place and you're looking around. You don't see anything that speaks to you, yet you feel good being there. As you look around, you realize there's a beam of light coming from a high window. It crosses the floor, and in that beam of light there's a little bit of dust floating. Suddenly you realize the most important thing in the whole space is that little beam of light, and in a few minutes it's going to disappear. The moment you recognize it, light has become your subject.

Any time you feel you don't know what to photograph or have no imagination, I urge you to look around and let light be your subject. Give yourself over to it for five minutes. Look at where it's coming from. Watch where it bounces off the floor and how it lights up the area around where it lands. See how it is when someone walks into it and it falls on their body.

Perhaps you see light bouncing off the bonnet of a car, glinting in an interesting way, or raking across the side of a building, or coming and going across a flag that's blowing in a breeze, or you notice dappled light in the woods.

If you let the light guide you, you will discover subjects that come alive because they are illuminated. Light charges your observations and connects you to your surroundings. You really will 'see the light'. It's there on those days when you are feeling flat, enabling you to really see what's around you.

When I was working in Cape Cod, there was a period when I found myself stunned by the simple fact of sunlight sliding across the surface of a building. I remembered the great American painter Edward Hopper, who, when asked what he was really painting, what his subject was, answered: 'I'm painting sunlight on the sides of houses.' What a simple thing to say.

What he meant was that simple things have a profound effect on us if we give ourselves over to them. By doing that in Cape Cod – by allowing myself to be moved by simple happenings – I was able to make enough work to gather together in a book (*Cape Light*; 1978). That book has served me incredibly well over the years, in that it has guided and reassured me, and helped me to find myself as I have served photography – the medium I believe in, the medium that gives me messages from the world at large.

The story behind it is that I had found myself needing to move away from the small camera, the 35mm Leica that I used on the street, to a larger-format camera, in this case an 8 by 10-inch wooden Deardorff camera. I wanted all the photographic detail that camera could deliver, so I made the switch. But a large-format camera doesn't work so well in a city environment, so I took myself to Cape Cod.

While I was photographing in Manhattan, or indeed any large city, energy and the kind of visual jazz riff you get on the street had been the subject of my work, but in Cape Cod I had to find a way to work with a slow, quiet atmosphere. I found myself photographing architecture, seascapes, sunlight on houses and portraits. Over time, these things developed in ways that surprised me.

One of the first things I discovered was that a large-format camera sees into the oncoming darkness. It's as if time adds light to the photograph. I found myself struck by the beauty of dusk and how this big camera could stand there, like a faithful companion, and show me all the information that was there.

Early in my time in Cape Cod, I developed a whole body of work around the idea of dusk, of 'entre chien et loup'. That French expression translates literally as 'between the dog and the wolf', but really it means between the known and the unknown, or the tame and the wild. That blue hour can sometimes evoke feelings of fear. There is also a kind of ambiguity, and that appealed to me.

Light can be a sparking point, then, something to excite your eye and get your mind working. By looking for the light you'll simply make a starting point, and without doubt you will move on to something unexpected that comes to you only because you followed that simple call to the light.

I can't guarantee this, of course, but from experience I can tell you that small observations generate others, and that step by step your reading of the place in which you find yourself grows in interesting and unpredictable ways. You'll have a chance to raise questions – playful, visual questions suggested by the place itself – about what else might be worth taking in, or being taken in by.

There is a magnetism about this process of opening yourself up to the suggestibility of place, of space, of time, light, the simple, the majestic, the ordinary, the sublime, or any connection that wafts across your open mind, and if you carry your camera regularly, you will learn to see. We all hope to see beyond the mundane and familiar visuals that have become clichés, and what better divining rod than a camera to take us into new territories of experience?

Many years ago, while I was living among Flamenco gypsies in Spain, someone said to me, 'We must spend ourselves freely'. I have taken that as my guide to photography and the potential it offers, and in my way of continuously adding new experiences to my life. By doing so I have been able to learn something of the mystery of this medium.

Edit your photographs

Give your work form and meaning

Editing is essentially a process of elimination and involves really getting to know the images you've made. It's about finding the very best of the however many photographs you have taken in a moment.

Editing is a way to thread together bits and pieces of time to make a pleasing, organized structure, something that has your personal poetry running through it. It is a joyous experience being out in the world, making photographs and then collecting your ideas and putting them in some kind of order. I find recognizing my ideas one of the greatest pleasures of photography. And it is essential if you hope to grow as an artist.

People often ask me how I know which of my pictures to choose, and how I can tell which are the best. First of all, it is a very personal experience, so for each of us it will be different. We need to be able to find just what it is that becomes the 'telling moment' in our work. Sometimes it goes back to the instant you made the photograph, the fraction of a second when something came to you and you *knew* that that was the moment you had to capture. That picture – the one made at that opportune moment, when everything came together – will stand out afterward. You'll just know.

But what if you were lucky and the thing you were photographing continued, and you moved with it and made a number of

Opposite: Contact sheet, 1964

pictures? Afterwards, inevitably you'll look for the one that sums up the entire experience, or that faithfully shows the action, the meaning, or the story.

At the same time, looking back over a stream of images you've made of a moment or a happening can be enlightening because it shows how you moved through time and kept pace with it, developing your understanding until the event reached a peak. Sometimes, across many pictures, you'll be able to see how your rendering of the subject has matured as your understanding and appreciation of what is unfolding have deepened.

'It can be really hard to know which is the best image... I trust my instincts.'

What do you do when you have several images with similar properties? One picture might have a little more space at the bottom, or a cluster of people might be denser in one part of the picture than in another. It can be really hard to know which is the best image. When I am hovering over a suite of photographs from the same moment and the decision is difficult, I trust my instincts to guide me to the strongest image. Often I'll be dealing with images that are not from the same sequence. They might be from many different places and perhaps made over several years, but I've collected them to try to edit them into something with a larger meaning, something I was working toward over a number of years.

You could also print out the images at playing-card size and compare them. I do this when I'm making a book: I'll often print many pictures at this size because I find it helpful to physically put my thoughts down on the table. I'll look from one to the other to see how the pictures hold up together, and I'll ask myself, 'Which add the most to the run of things? Which don't really bring anything to the mix, or - worse - take away from the strongest elements of the edit?'

Whether you're editing a group of images you've just made or some from the past, looking at them as prints gives you a chance to reflect. The experience of looking at a print is very different from that of viewing an image on screen. A photograph might

look really great on your computer, but it *must* hold up as a print. In any case, it is easier to sequence a run of images that you want to consider on a tabletop, or hold them in your hands and flip through them as though you are holding a miniature of the book you are trying to make. There is more time for contemplation.

If you're lucky you might find that you get what I call 'sticky finger' syndrome. Do you remember those cartoons where some-body got something stuck to their hand and tried to get rid of it, to no avail? Sometimes pictures are like that. They stick to you, and you think, 'OK. Something in me is not letting me throw that one away.' Trust that. The images that matter are those that keep coming back and demanding you reconsider them.

Then there are the occasions when an argument occurs between two images. If that happens, think about the bigger picture – as in, the outcome you're aiming for. Perhaps you're working toward a book. If you have a pair of images vying for attention, think about which is the strongest in relation to the others around it and to the edit as a whole. Where do you want the images to take you and the viewer? Look at how the pictures work with each other.

Use your mind, your emotions and your intuition to make decisions, because that is how you will learn to refine everything you know or care about in photography. If you're feeling indecisive, take a risk, put in something that you were thinking about but kept rejecting. See how that sends shock-waves both back and forward.

Let's go into this a little deeper. Say I've just come back from a day's work and shot 450 or so frames. I've loaded the images into Lightroom, but what next? Well, I sit back and give myself a tour of what I saw. I enlarge the images so they're screen size and just go through them, reacquainting myself with those moments. 'Ah, that light was beautiful,' I might think, or 'That group's energy went slack,' and then I'll remember how I went with an unexpected twist in their behaviour.

I've used this approach since I started photography. I do it to familiarize myself with the overall content. Think of everything you've shot as the story of your interests during the period in which you were making those pictures. What were you drawn to? The quality of the light? Tiny things far away in a big space?

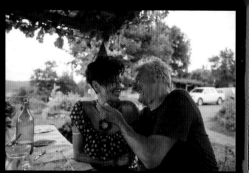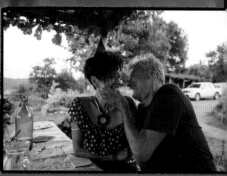

Close-ups? What was going on for you during that trip?

I don't make any selections during the first go-through.

If you 'read' the overall story first (and I don't mean a 'story' story, rather the story of your interests being played out through the day), you'll get a sense of the leanings, passions and questions you had, which are part of who you are. After you've familiarized yourself with those images, let them rest.

Come back the next day and look at the images again. Any time your impulse says, 'I like that', give it a star rating. Don't even think twice. If you like it, mark it and move on to the next. When you've been through everything, choose to view all the starred images. Say you have 90. Wow – 90 impulses out of 450! That's not quite 25 per cent, but it's pretty good.

Then look at those 90 images and begin to whittle them down. Be instinctive, and keep on going through them. Give yourself time to do this, and enjoy the process. Very often, when you come back after a day's shooting and are excited to see your pictures, you're likely to make hasty decisions. It's better to let them sit awhile and take a moment to collect yourself.

After a couple of days you might end up with 20 pictures that you feel really capture the sense of what you saw, and who you were while you were shooting. That's your cut. Don't question those 20 pictures again, at least not yet. Just print them out at whatever

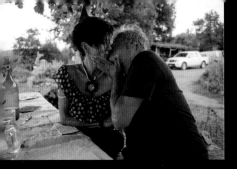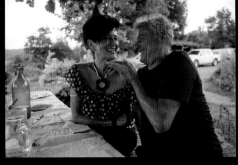

size suits you. I like to print mine at a fairly good size so that I can read them and enter the moment again.

That's how you build your archive, by repeating this process every time you go out photographing. If you keep doing that, eventually you'll have hundreds of photographs that you really want to look at. Those photographs, carefully distilled over time, form the big picture, what we might call 'your photography'. From them you'll be able to pick, say, 50 that are killer photographs that communicate to anyone who looks at them.

I believe the editing process is you refining your identity. And when someone looks at your photographs they will know that it was you who made them because they can instantly see the clarity with which you perceive and appreciate the world.

Here's a contact sheet (above) of a couple who was having a moment of 'love play' while I was at a table with them. There were many more photographs around these, but this sequence of four shows when the moment of the action peaked. I'm sure that some would prefer the initial moment, while others might say that the kiss is the payoff. True, either of these could work. But for me it's the second frame, where the space between them shows what's to come, and where the man's loving hand prepares to caress the woman's face, while she is expressing a sweet and sexy anticipation in her eyes and smile. This image for me has all the elements of romance, and it's the one I would select.

Above:
Luana and Gianni,
Tuscany, 2019

Acknowledgments

This work wouldn't have come into existence without the original vision of Chris Ryan, the creator of the Masters of Photography Online course. Chris shaped the entire series, and as the director he drew me out in ways both professional and personal. Perhaps the most fun – after filming the series itself – was working with Gemma Padley on the texts. She was like a great tennis partner as we whacked the text back and forth always making it more supple and accurate while maintaining the spin and the speed of the spoken word. My studio director, Katya Barannik, devoted herself to providing all the support imagery needed for the videos and the book, and for her help I am immensely grateful. Both Melissa Danny and Blanche Craig at LKP have been untiring in their efforts to keep the book on track and for helping me tie up all loose ends I am thankful for their support.

– Joel Meyerowitz

There is no finer artist, teacher and friend with whom I would want to walk alongside on this journey to explore photography than Joel Meyerowitz. Joel's precision in articulating his ideas and concepts are like beautiful artistic arrows that hit straight into the bullseye every time.

Thank you Joel, for being such an inspirational guide and mentor on this project, for your huge generosity of spirit and willingness to share your photographic ethos with all of us. Joel openheartedly encourages me and every one of his students to 'come walk with me and lets see what we can discover'. It's an ongoing exploration that will never cease to direct me to higher paths and better creative thinking.

Very special thank you to my Masters of Photography co-founder Gilles Storme for all his generous support and constant help from the very start. Thank you to our creative director Robin Harvey and our legal council Alex Weiner for all your support in bringing the whole concept to life. A huge thank you and hug to our wonderful Masters of Photography team; Nick Mays, Olivia Harvey, Camilla Wyatt, James Stringer and Patrick Rutledge.

Thank you to our film crew and post production team, Producer Will Daunt, Cameraman Josh Lee, Film editor Rob Jury and our Colourist James Willet forall their months of brilliant work creating the incredible filmed lessons that this book is derived from.

An enormous thank you to everyone at Laurence King Publishing for supporting and guiding us all at Masters of Photography through your careful and beautiful process of creating this book.

– Chris Ryan
Founder, Masters of Photography

About the authors

Joel Meyerowitz

Joel Meyerowitz (born in New York, 1938) is an award-winning photographer whose work has appeared in over 350 exhibitions in museums and galleries around the world. Celebrated as a pioneer of colour photography, he is a two-time Guggenheim Fellow, a recipient of both National Endowment for the Arts and National Endowment for the Humanities awards, and a recipient of The Royal Photographic Society's Centenary Medal. He has published 30 books.

Masters of Photography

The aim of Masters of Photography is to bring together the greatest master photographers in the world, to teach and guide us all. These are not technical camera courses. These are inspiring and intimate one-to-one lessons that capture their knowledge, ethos and philosophy. We wanted to create a side-by-side walk with our master photographers, as they teach us how to use our eyes and minds to frame and create photographs that interpret our own vision of the world around us.

Photo acknowledgments

13: © Henri Cartier-Bresson/Magnum;
15: © The Estate of Diane Arbus. Courtesy Fraenkel Gallery, San Francisco.